MEMORY AND METAPHOR

Frontispiece Romare Bearden, *Photo: Chester Higgins, Jr.*

MEMORY AND METAPHOR
The Art of Romare Bearden 1940–1987

Introduction by Kinshasha Holman Conwill

Essays by Mary Schmidt Campbell and Sharon F. Patton

THE STUDIO MUSEUM IN HARLEM
New York

OXFORD UNIVERSITY PRESS
New York • Oxford

1991

Oxford University Press

Oxford New York Toronto
Delhi Bombay Calcutta Madras Karachi
Petaling Jaya Singapore Hong Kong Tokyo
Nairobi Dar es Salaam Cape Town
Melbourne Auckland

and associated companies in
Berlin Ibadan

Published by Oxford University Press, Inc.,
200 Madison Avenue, New York, New York 10016

Oxford is a registered trademark of Oxford University Press

Library of Congress Cataloging-in-Publication Data
Bearden, Romare. 1912–1988
Memory and Metaphor: The Art of Romare Bearden, 1940–1987 /
introduction by Kinshasha Holman Conwill;
essays by Sharon F. Patton and Mary Schmidt Campbell.
p. cm. Catalog of an exhibition to be held at the
Studio Museum in Harlem and in five other cities.
Includes bibliographical references.
ISBN 0–19–506347–3 (cl)
ISBN 0–19–506348–1 (ppr)
1. Bearden, Romare, 1912–1988—Exhibitions. I. Patton, Sharon F.
II. Campbell, Mary Schmidt. III. Studio Museum in Harlem. IV. Title.
N6537.B4A4 709′.2–dc20 90–22635

9 8 7 6 5 4 3 2 1

Printed in Japan

This catalogue is published on the occasion of the exhibition "Memory and Metaphor: The Art of Romare Bearden, 1940–1987," organized by The Studio Museum in Harlem.

This exhibition and publication have been made possible through a generous grant from The Henry Luce Foundation, Inc. Additional support was provided by The New York State Council on the Arts, and a National Endowment for the Arts Challenge Grant. Operation of the Museum's facility is supported in part with public funds provided through the New York City Department of Cultural Affairs.

The exhibition and its national tour are sponsored by Philip Morris Companies Inc.

Exhibition itinerary: The Studio Museum in Harlem, New York, April 14, 1991–August 11, 1991; Museum of Contemporary Art, Chicago, Illinois, September 28, 1991–November 10, 1991; Wight Gallery, University of California, Los Angeles, California, December 8, 1991–February 2, 1992; High Museum of Art, Atlanta, Georgia, March 10, 1992–May 3, 1992; The Carnegie Museum of Art, Pittsburgh, Pennsylvania, May 30, 1992–July 25, 1992; National Museum of American Art, Smithsonian Institution, Washington, D.C., October 2, 1992–January 4, 1993.

Memory and Metaphor: The Art of Romare Bearden, 1940–1987 is published in honor of the following Studio Museum in Harlem benefactors:

DIRECTOR'S CIRCLE

Dr. Beny Primm
Patricia T. & David V. Smalley

PATRONS

Robert Allen
Gregory J. Anderson
Anonymous
Alberta Arnold
Lily Auchincloss
Mr. & Mrs. Mario L. Baeza
Bill Blass
Ed Bradley
Mr. & Mrs. Peter Carley
Janet Carter
Richard V. Clarke
Emma Condit
Norma Jean Darden
Oscar de la Renta
D. Olivia De Prator
Harold Freeman
Mrs. Johnson Garrett
Elliot Hall
Wanda G. Henton
Ann Hutchinson
George L. Knox
Raymond Learsy
Robert Lieberman
Mr. & Mrs. Henry W. McGee, III
Sharon and Alric Nembhard
Richard Newman
Honorable and Mrs. Charles Rangel
Vernon A. Reid
Gail Shiva
Bobby Short
Forrest L. Smith

Dr. & Mrs. Donald M. Stewart
Dr. Robert M. Streeter
H. Van Ameringen
Irene & Herbert G. Wheeler
John Hay Whitney
Herbert Wight
Mr. & Mrs. E. Thomas Williams, Jr.

DONORS

Rae Alexander-Minter and Thomas K. Minter
Carl Bradford
Drs. Mary & George Campbell
Kenneth I. Chenault
Kinshasha & Houston Conwill
Evelyn Cunningham
Elizabeth De Cuevas
Marilynn A. Davis
Louis Ganz
Beverly Hemmings
Bertina Carter Hunter
Olga Jenkins
Vernon Jordan
Moonyene S. Jackson, Esq.
Harley Jones
Willa M. Jones
Nancy L. Lane
Susan Lindenauer
Shahara and Bruce Llewellyn
Arthur Loeb
Mary Ann Madden
Joel Motley
Mrs. Maurice T. Moore
William Pickens, III
Linda F. Rankin, M. D.
Major E. Thomas, Jr.
Martin V. Waters

This catalogue is published on the occasion of the exhibition "Memory and Metaphor: The Art of Romare Bearden, 1940–1987," organized by The Studio Museum in Harlem.

This exhibition and publication have been made possible through a generous grant from The Henry Luce Foundation, Inc. Additional support was provided by The New York State Council on the Arts, and a National Endowment for the Arts Challenge Grant. Operation of the Museum's facility is supported in part with public funds provided through the New York City Department of Cultural Affairs.

The exhibition and its national tour are sponsored by Philip Morris Companies Inc.

Exhibition itinerary: The Studio Museum in Harlem, New York, April 14, 1991–August 11, 1991; Museum of Contemporary Art, Chicago, Illinois, September 28, 1991–November 10, 1991; Wight Gallery, University of California, Los Angeles, California, December 8, 1991–February 2, 1992; High Museum of Art, Atlanta, Georgia, March 10, 1992–May 3, 1992; The Carnegie Museum of Art, Pittsburgh, Pennsylvania, May 30, 1992–July 25, 1992; National Museum of American Art, Smithsonian Institution, Washington, D.C., October 2, 1992–January 4, 1993.

Memory and Metaphor: The Art of Romare Bearden, 1940–1987 is published in honor of the following Studio Museum in Harlem benefactors:

DIRECTOR'S CIRCLE

Dr. Beny Primm
Patricia T. & David V. Smalley

PATRONS

Robert Allen
Gregory J. Anderson
Anonymous
Alberta Arnold
Lily Auchincloss
Mr. & Mrs. Mario L. Baeza
Bill Blass
Ed Bradley
Mr. & Mrs. Peter Carley
Janet Carter
Richard V. Clarke
Emma Condit
Norma Jean Darden
Oscar de la Renta
D. Olivia De Prator
Harold Freeman
Mrs. Johnson Garrett
Elliot Hall
Wanda G. Henton
Ann Hutchinson
George L. Knox
Raymond Learsy
Robert Lieberman
Mr. & Mrs. Henry W. McGee, III
Sharon and Alric Nembhard
Richard Newman
Honorable and Mrs. Charles Rangel
Vernon A. Reid
Gail Shiva
Bobby Short
Forrest L. Smith

Dr. & Mrs. Donald M. Stewart
Dr. Robert M. Streeter
H. Van Ameringen
Irene & Herbert G. Wheeler
John Hay Whitney
Herbert Wight
Mr. & Mrs. E. Thomas Williams, Jr.

DONORS

Rae Alexander-Minter and Thomas K. Minter
Carl Bradford
Drs. Mary & George Campbell
Kenneth I. Chenault
Kinshasha & Houston Conwill
Evelyn Cunningham
Elizabeth De Cuevas
Marilynn A. Davis
Louis Ganz
Beverly Hemmings
Bertina Carter Hunter
Olga Jenkins
Vernon Jordan
Moonyene S. Jackson, Esq.
Harley Jones
Willa M. Jones
Nancy L. Lane
Susan Lindenauer
Shahara and Bruce Llewellyn
Arthur Loeb
Mary Ann Madden
Joel Motley
Mrs. Maurice T. Moore
William Pickens, III
Linda F. Rankin, M. D.
Major E. Thomas, Jr.
Martin V. Waters

CONTENTS

SPONSOR STATEMENT

"The true artist feels that there is only one art—and that it belongs to all mankind."
Romare Bearden

Philip Morris first became involved with the work of the late Romare Bearden in 1976, when we sponsored "Two Centuries of Black American Art." The exhibition was the first major historical survey of African-American contributions to our country's culture.

As firm believers in the creative power of the American spirit, in all its multiplicity and diversity, we later sponsored "Romare Bearden: 1970–1980." In fact, we have encountered this remarkable and versatile American artist in numerous exhibitions and publications we have supported.

Over the years we have grown to know his work well, and hope others will now give Bearden the recognition he truly deserves. As he worked and resided in Harlem for twenty years, it is fitting that The Studio Museum in Harlem has chosen to organize this landmark exhibition.

The Studio Museum has assumed the vital task of securing for Bearden· a rightful place at the core of our national culture. Philip Morris is proud to join in this celebration of an artist whose work "belongs to all mankind."

Hamish Maxwell
Chairman and Chief Executive Officer
Philip Morris Companies Inc.

ACKNOWLEDGMENTS

The Studio Museum in Harlem is proud to present this exhibition—the first major retrospective of Romare Bearden's career since the artist's death—and the accompanying catalogue. This exhibition is one of the major statements defining the Museum and our mission as it relates to the role of African American artists in the history of American art.

Our ability to mount this multifaceted project is a reflection of the vision and talent of many individuals and organizations. From the project's inception, The Henry Luce Foundation exemplified their commitment to an inclusive art history with their support and encouragement. Philip Morris Companies Inc. defined the word patron with their sponsorship of several aspects of the exhibition, including the national tour, which will bring this remarkable presentation to five American cities. Our special thanks go to the individuals within these organizations who took a personal role in bringing this project to fruition. At the Luce Foundation, we are grateful to Henry Luce III, Robert Armstrong and, especially, Mary Jane Crook. At Philip Morris, we would like to acknowledge the special efforts of Museum trustee George Knox, and Stephanie French and Karen Brosius.

Mary Schmidt Campbell, New York City Commissioner of Cultural Affairs and my predecessor as Director, was integral to the realization of the exhibition and this publication. As the premier Bearden scholar, she provided us with new directions and insights. Without her essay, this catalogue would be a lesser document. We are grateful to Joyce Berry, Senior Editor at Oxford University Press, who oversaw the publication of the catalogue. We would also like to acknowledge Nanette Rohan Bearden and Madeline Rabb.

Thanks to all of The Studio Museum in Harlem trustees and staff for their support of this project. The Board's united commitment to this exhibition led us to this point. Board Secretary Marie Dutton Brown was instrumental to the planning and realization of this publication. Our Chairman Joel Motley, First Vice Chairman Major E. Thomas, Trustees Evelyn Cunningham, Melvin Edwards, Nancy Lane (who was Board Chair at the project's inception), and Michael Winston all provided invaluable advice and counsel.

On the staff, Chief Curator Dr. Sharon F. Patton gave a great deal of time and talent to this huge undertaking. The careful selection of representative works for the exhibition was achieved through considerable reflection, negotiation, and travel. Funding for the exhibition was secured through the excellent work of Patricia Cruz, Deputy Director for Programs, Linda Williams Bowie, Development Director, and their staffs. Ms. Cruz also offered her energy and imagination to the exhibition's interpretive programs. George Calderaro, Public Relations Coordinator, added his expertise to the promotional aspects of this project.

Finally, I would like to thank the institutions who will present this exhibition to their constituencies nationwide: the Museum of Contemporary Art, Chicago; the Wight Art Gallery, University of California, Los Angeles; the National Museum of American Art, Smithsonian Institution, Washington, D.C.; The High Museum of Art, Atlanta; and The Carnegie Museum of Art, Pittsburgh. Through the commitment of these institutions and my colleagues at each of them, the world of ideas which Romare Bearden brought to light will enrich new audiences and inspire future generations.

Kinshasha Holman Conwill
Executive Director

Any exhibition and publication of this scope owes much to the efforts and support of individuals and institutions. First I give a special thanks to Executive Director of The Studio Museum in Harlem, Kinshasha Holman Conwill, for her timely proposal to present this exhibition, and giving me the opportunity to undertake this exciting project.

Second, I thank The Studio Museum in Harlem Trustees and staff for their support of the exhibition and the catalogue. I especially thank trustee Marie Brown, whose advice and moral support were essential during the preparation of the work. I gratefully acknowledge the following people on the staff of the Museum, whose invaluable assistance made this exhibition and publication possible: Senior Registrar Jon Hutton, Archivist Naomi Nelson, Assistant Registrar Mark Branch, and Public Relations Coordinator George Calderaro. No exhibition or catalogue occurs without the diligent "behind-the-scenes" efforts of support staff: Curatorial Assistant Keith M. Woods, Archival Intern Milton Quinones, and former research assistant Yasmin Ramirez.

The completion of this manuscript owes much to Joyce Berry, Senior Editor, Oxford University Press. My thanks to the staff at the University Press whose efforts made this publication possible. Also the readings and comments of drafts by Shirley Poole and Susan Meigs were helpful in preparation of the essays by myself, Dr. Campbell and Mrs. Conwill.

More important, without the cooperation of museums, art galleries, corporations, and private collectors this exhibition would not have hap-

pened. I also thank the staff of these art institutions, for their cooperation and understanding of production schedules at critical times during this project.

The institutions which lent works for this exhibition are: Albright-Knox Art Gallery, Buffalo, New York; Amistad Research Center, New Orleans, Louisiana; Arkansas Art Center, Little Rock, Arkansas; The Brooklyn Museum, New York; Bryn Mawr College, Bryn Mawr, Pennsylvania; Butler Institute of American Art, Youngstown, Ohio; Carnegie Museum of Art, Pittsburgh; Clark Atlanta University, Atlanta, Georgia; Crocker Art Museum, Sacramento, California; Davidson College Art Gallery, North Carolina; The Carl Van Vechten Gallery of Fine Arts, Fisk University, Nashville, Tennessee; Flint Institute of Art, Flint, Michigan; High Museum of Art, Atlanta, Georgia; Hirshhorn Museum and Sculpture Garden, Smithsonian Institution, Washington, D.C.; Howard University, Gallery of Art, Washington, D.C.; Madison Art Center, Milwaukee, Wisconsin; The Metropolitan Museum of Art, New York; Mint Museum, Charlotte, North Carolina; The Museum of Fine Arts, Boston, Massachusetts; The Museum of Modern Art, New York; National Museum of American Art, Smithsonian Institution, Washington, D.C.; Neuberger Museum, State University of New York at Purchase, New York; Newark Museum, Newark, New Jersey; Schomburg Center for Research in Black Culture, Art and Artifacts Division, The New York Public Library, New York; Spelman College, Atlanta, Georgia; The Studio Museum in Harlem, New York; University Art Museum, Berkeley, California; University of Oklahoma Museum of Art, Norman, Oklahoma; Wadsworth Atheneum, Hartford, Connecticut; and the Whitney Museum of American Art, New York. My thanks to the corporations whose loans ensured a quality exhibition and complimented museum and university collections. They are CIBA-GEIGY Corporation, Ardsley, New York; Philip Morris Companies Inc., New York, and Chase Manhattan Bank, N.A., New York.

Several galleries were instrumental in identifying and making available works for the exhibition. I thank them for their support, and their assistance in securing loans of works for this exhibition. They are: ACA Galleries, New York; Peg Alston Fine Arts, New York; Malcolm Brown Gallery, Cleveland, Ohio; Cordier & Ekstrom, Inc., New York; Sid Deutsch Gallery, New York; Alitash Kebede Fine Arts, Los Angeles, California; June Kelly Gallery, New York; McIntosh Gallery, Atlanta, Georgia; Jerald Melberg Gallery, Charlotte, North Carolina; Larry Randall Galleries Ltd., New York; Sheldon Ross Gallery, Birmingham, Michigan; and Wendell Street Gallery, Boston, Massachusetts.

Numerous private collectors made their collections available for this show and publication. Their willingness to show their works and loan to the exhibition is an indication of their love and greatest admiration for the artist. Many are anonymous. Others, I wish to thank: Billie Allen, New York; Peg Alston, New York; Herman Binder, Farmington, Michigan; Evelyn Boulware, New York; Richard V. Clarke, New York; Linda and

Person Cummin III, Greenwich, Connecticut; Mr. and Mrs. Richard Doerer, Grosse Pointe, Michigan; Mrs. James Dugan, Philadelphia; the Duke Ellington Family, New York; Dr. Walter O. Evans, Detroit, Michigan; the Freedom Place Collection, Washington, D.C.; Herbert Gentry, New York; Laura Grosh and Herb Jackson, Davidson, North Carolina; Beatrice and Harry Henderson, Croton-on-Hudson, New York; June Kelly, New York; Rowan Khaleel, New York; Dr. Florence Ladd, Cambridge, Massachusetts; R. L. Lewis, New York; Mr. and Mrs. Reuven Merker, Englewood Cliffs, New Jersey; Lou Milano, Charlotte, North Carolina; Dr. and Mrs. S. Nagel, Southfield, Michigan; Mr. and Mrs. Sam Pearlstein, Southfield, Michigan; Dr. and Mrs. Harold Plotnick, Franklin, Michigan; Dr. Beny Primm, New York; Eleanor Quirt, Minnesota; Sheldon Ross, Huntington Woods, Michigan; Gerhard and Ute Stebich, Plainfield, Massachusetts; Philip J. and Suzanne Schiller, American Social Commentary Art 1930–1970, Highland Park, Illinois; Jane and David Shapiro, Washington, D.C.; Marvin and Morgan Smith; the Estate of William H. Van Every Jr., Charlotte, North Carolina; Barbara Wallace, Philadelphia; Gladys and Russell Williams, New York; Mr. and Mrs. E. Thomas Williams, Jr., New York, and Aida Bearden Winters, New York.

There are particular individuals whose remembrances and perceptions about Romare Bearden's art and the man were enlightening—Billie Allen, Constance Brown, Ernest Crichlow, Arne Ekstrom, Herbert Gentry, Russell Goings, Harry Henderson, Chester Higgins, June Kelly, Jacob Lawrence, Richard Mayhew, Eleanor Quirt, Sheldon Ross, Myron Schwartzman, Jane Shapiro, Marvin Smith, and Barry Stavis. A special note of appreciation to them.

There are also institutions whose archival resources I consulted in preparation for my essay on Bearden's art: the Archives of American Art, Smithsonian Institution, New York, and Washington, D.C.; Hatch-Billops Archives, New York; Museum of Modern Art Library, New York; Schomburg Center for Research in Black Culture, The New York Public Library, New York; Whitney Museum of American Art Library, New York.

I wish to also thank Dawoud Bey for his excellent photographic work, and the other photographers whose dedication to quality made us greater appreciate the nature of Bearden's paintings. I thank J. R. Sanders of Sanders Design Works for the design of the exhibition.

Sharon F. Patton
Chief Curator

MEMORY AND METAPHOR

INTRODUCTION

Kinshasha Holman Conwill
Executive Director
The Studio Museum in Harlem

Early in 1988, The Studio Museum in Harlem decided to do a full retrospective of the art of Romare Bearden. We were motivated by a determination that the record on Bearden be set straight. Further, we were bolstered by our years of experience, not only with Bearden but also with our own record of primary research on African-American artists and our efforts to bring their work visibility and critical attention. From the outset we were convinced of two points: that the retrospective should be accompanied by a major publication and that it should travel widely. Certainly we were aware of previous research, writings, and exhibitions on Bearden and were clear that our undertaking must be substantially different. First, we wanted to examine Bearden's entire career, addressing gaps in previous exhibitions that examined earlier periods of the artist's life and bringing the work of his later years into focus. Second, we wanted the scope of the exhibition to be matched by a depth of scholarship, a breadth of programming, and major funding to support the ambitiousness of the overall project. With this publication we are achieving one of these goals, adding significant and heretofore unpublished information about Bearden to the art historical record.

That the exhibition is being organized by The Studio Museum in Harlem is significant, too. Dr. Mary Schmidt Campbell, the Museum's director for a decade, is the major scholar on Bearden. Bearden loved and revered Harlem and was closely identified with the Museum, serving on the Curatorial Council and frequently attending Museum events and programs. It was here that younger artists had an opportunity to share a private moment with Bearden—to be greeted with respect, warmth, and humor by one of the twentieth century's most important American artists.

Bearden's seminal work, *Conjur Woman* (1964), a cornerstone of the Museum's collection, was a gift from the artist. He was twice recipient of the Museum's Artist Award, the first time jointly with Elizabeth Catlett and Jacob Lawrence in 1983, the second time in a posthumous award to his widow Nanette Rohan Bearden in 1988. Bearden's art and the history and concerns of the Museum are also closely linked to an African-American experience that is complex in its connotations—triumph, loss, joy, possibility, and, ultimately, transformation. Much as the African-

American community mediates these seemingly contradictory experiences through rituals of kinship, memory, and belief, so this undertaking embraces Bearden and names him, once again, as our own.

With the exhibition itself, opening at The Studio Museum and then traveling to Chicago, Los Angeles, Atlanta, Pittsburgh, and Washington, D.C., we plan to give the public an opportunity to see the work of Bearden on a scale not previously possible. More than one hundred of his works will be displayed (previous major exhibitions have had fewer than sixty), including key pieces that either have never been exhibited or were not presented in context with works of other periods.

When Bearden died in 1988 at age seventy-five, there had not been a full retrospective of his work in seventeen years. For an American artist of his stature, influence, and achievement, the timing and scope of exhibitions devoted to his art were either generous or insufficient, depending on one's perspective. In a period when it was not uncommon for American artists to have several one-person exhibitions throughout their careers, Bearden's three major museum shows in a decade and a half would seem appropriate.[1] Bearden was nearly sixty when he had his first major museum exhibition, and the two succeeding exhibitions each dealt with only a decade of his career. This record—and the reading of it—suggests something about how he was perceived.

It also suggests that there were two Romare Beardens. One inspired August Wilson, the Pulitzer Prize-winning playwright, to write the play *The Piano Lesson* (after Bearden's work of the same name).[2] Among American artists, Bearden was generally admired, imitated, and loved, and young African-American artists held him in almost reverential regard. One senses that Wilson found Bearden a model for how he approached and took command of his subject matter, as well as how he lived as an artist. Bearden's ability to hold to his vision in an inhospitable art world yet keep his integrity intact was a vital lesson for those who followed in his footsteps, especially for younger visual artists.

The other Bearden was a considerably diminished figure. Mary Campbell asserts that "in spite of all the accolades, in spite of the critical praise and his success in the marketplace [Bearden's] recognition was not converted into acknowledgement in recorded history." Thus while Bearden lives on in a prolific and majestic body of work—and in the hearts and minds of his admirers—to a larger group, and in a larger sense, his importance to American art is, relative to his significance, insufficiently documented.

This exhibition, then, is an attempt to "remember" and "reassess" the "two" Romare Beardens and to place his work in its fullest context. In previous attempts to accomplish this, inadequate attention has been given the complexity and depth of his sources and intentions, and the uses to which he puts them. Instead, previous analysis has tended to depend on a single matrix, whether biographical or formalist, or a superficial reading of his work as "lyrical" or "romantic," or a consideration of the influence of blues and jazz. Whatever the mode or content of such analysis, much of

it ultimately served to minimize or diminish (if not dismiss) Bearden's larger role. Sharon F. Patton, Chief Curator of The Studio Museum and curator of the exhibition, notes that the artist "reconstructs his own life's history and the culture of African Americans," and that his art is "essential for the history of contemporary American art." Mary Campbell suggests that it is finally Bearden's embrace of a multiplicity of influences, sources, and traditions that make his work difficult to reconcile for many American curators and critics unable (or unwilling) to absorb work that challenges the limits of conventional art historical analysis.

This exhibition is part of a larger undertaking—the reassessment of Bearden's contribution to American art. Mary Campbell's critical research has laid the groundwork for much of what has been done to examine Bearden and it will continue to influence future study. Her essay for this publication and her forthcoming biographical study of Bearden will remain required reading on the artist and American art. Sharon F. Patton has assembled the most comprehensive survey of Bearden's work ever, an overview of his entire oeuvre, including works of the 1980s and earlier pieces that have never before been exhibited. She has traveled across the country to research collections and has engaged scholars and experts to advise on the exhibitions and its programs. Ideally, the reassessment of Bearden's work and career will continue, and our efforts will serve as a catalyst for further study. For Romare Bearden has much to teach us about African-American culture and American art.

The Studio Museum is fitting for the exhibition because Harlem was home to Bearden for many years. But it is Harlem as metaphor as well as touchstone, fertile source, and nurturer that makes this site so appropriate. A sense of community is the secret weapon of African-American artists. For artists like Bearden, perceived as outsiders in the larger art world, the Harlems of the world (and the Pittsburghs and Charlottes) serve to reveal these artists for what they are—the ultimate insiders. They address a larger arena from within the communities where they gain authority and, in a circle of validation, are in turn empowered by the authentic culture from which they spring. The culture's values and inventions are then validated and celebrated by the art that the artist produces. This exhibition of work is also circular: for just as Bearden celebrated the richness of African-American culture, this exhibition celebrates his singular contribution to American art.

This exhibition, therefore, is an act of bearing witness. It is, in the tradition of African-American culture, a homecoming, one endowed with all the richness and complexity that characterize such signal events—many of them so powerfully evoked in Bearden's work—as baptisms, weddings, and funerals. It is a memorial and a summing up. And if a musical motif can be assigned here, it is the music of the second liners of funerals in New Orleans—those musicians and revelers who lead mourners back from the cemetery after burial and whose upbeat rhythms are in marked contrast to the dirges that precede them. As we take the journey through the territory that is Romare Bearden's life work we will

do well to keep in mind not funeral dirges, but the joyous anthem of the second liners, "When the Saints Come Marching In," an appropriate tune for a long overdue canonization.

Notes

1. The major exhibitions of Bearden's work since 1971 were "Romare Bearden: The Prevalence of Ritual," organized by The Museum of Modern Art; "Romare Bearden 1970–1980," organized by the Mint Museum in Charlotte, N.C.; and "Romare Bearden: Origins and Progressions," organized by the Detroit Institute of Arts. All three exhibitions had national tours. "The Prevalence of Ritual" was also exhibited at The Studio Museum in Harlem.
2. Mervyn Rothstein, "Round Five for a Theatrical Heavyweight." *New York Times,* 15 April 1990, p. C8. According to Rothstein, Bearden's "Mill Hand's Lunch Bucket" also inspired Wilson to write *Joe Turner's Come and Gone.*

HISTORY AND THE ART OF ROMARE BEARDEN

Mary Schmidt Campbell
Commissioner
City of New York
Department of Cultural Affairs

History has had a difficult time with the art of Romare Bearden. At the outset of his career, he was a conventional Social Realist painter and his place in the history of American art was relatively easy to determine. His paintings of the period 1937–1941 fit neatly into the prevailing fashion of the 1930s, when many American painters, supported by the federally funded New Deal relief programs—the Federal Arts Projects of the Work Projects Administration (FAP/WPA)—subscribed to an "art for the people" aesthetic, a representational style steeped in social issues. Bearden's paintings of Black life in the South and of the migrants who came North seemed to be yet another variation of the Social Realist theme. Although there were hints of the rich mythic content and poetic narrative that filled his canvases later in his career, stylistically, there was little to distinguish these early works from that of other painters of the period. His works were part of a pantheon that included Ben Shahn, Jacob Lawrence, Philip Evergood, and the Mexican muralists, Diego Rivera and José Orozco. One noted historian of American art, Oliver Larkin, was especially critical in comparing Bearden's easel paintings to the magisterial murals of Hale Woodruff and Charles White. He wrote in his 1948 monumental study *Art & Life in America* that Bearden's art was "stiffly archaic and willfully primitive." Had Romare Bearden stopped painting before World War II, he no doubt would have been relegated to the role of a minor social realist painter of the WPA years.

But, as time would prove, Romare Bearden was not a conventional painter; quite the contrary. After World War II, his aesthetic choices gradually began to diverge from the mainstream and, as they did, his place in the history of American art grew more tenuous and difficult to define. Historians often found Bearden difficult to categorize because, as his career progressed, his paintings always seemed to be slightly out of step with those of his peers. When Abstract Expressionists were painting large nonfigurative works on unstretched canvas in the late 1940s and early 1950s, Bearden was painting small oils based on classical literary works. The historian Irving Sandler, whose text *The Triumph of American Painting* is a definitive study of the emergence of Abstract Expressionism, omitted Bearden, though he was represented by the same gallery as many

of these avant-garde artists and often was exhibited with Adolph Gottlieb, Robert Motherwell, and William Baziotes in the early years of the movement. In the late 1950s and early 1960s, Bearden was out of synch again when figures and objects re-entered painting via Pop Art, and minimalism's lean efficient surfaces were the abstract vocabulary then in vogue. Bearden, again swimming against the tide, chose to paint in the style of the Abstract Expressionists, using large canvases filled with expressive explosions of paint. In 1964, he abruptly abandoned his nonobjective oil paintings (and with them any connection to the American mainstream), when he began making his collages—works filled with cryptic figures and a dense symbolism that looked like nothing else in American art. Having lived with a number of different ideas of art, he had come back to the subject matter he started out with—Black American life as he remembered it in the South of his childhood in North Carolina, and in the North of his coming of age in Pittsburgh and Harlem and, later in life, the Caribbean island of St. Martin. Bearden's use of collage made everything in his career up to then seem to have been a restless search culminating in his discovery of collage and rediscovery of the value of his own life and culture. It was like an aging explorer who finally had stumbled upon the shores of a new, long-sought territory, and, for the next twenty-five years until his death in 1988, Bearden set out to explore this new world and in his words to "establish a world through art in which the validity of my Negro experience would live and make its own logic."

There is no question that the logic of Bearden's new world was foreign to most observers. As the critic Charles Childs wrote in *ArtNews* when Bearden's new work first appeared, the collages were "like a personal dictionary whose self definition is its own voice and its own authority." This personal dictionary contained not only a new visual vocabulary, with its own grammar and syntax, but also a self-sufficient set of thematic relationships based on a unifying philosophical content. The "Prevalence of Ritual" is what Bearden named this philosophy, and it remained the unifying basis for his art until the end of his career.

In spite of their unfamiliar imagery, Bearden's collages received almost unanimous acclaim. Critics well versed in the history of twentieth-century art immediately recognized his new work as a major contribution to the collage medium. Collage, quintessentially twentieth-century language, was introduced to modernism by Picasso during his Cubist experiments. The medium was augmented in the early years of the twentieth-century by the Surrealists, who expanded the vocabulary to include irrational, dreamlike juxtapositions. Dadaists then added the photomontage technique, as well as trenchant social commentary. Later, Matisse's *papier collé* imbued collage with great formal beauty. Bearden's work fully acknowledged this modernist lineage, making use of the full range of the medium—the Cubist balance between reality and illusion, the surrealistic dreamlike qualities, Dada's semijournalistic social commentary, and the sheer sensual beauty of the colors and textures of cut paper to convey the history and ceremonial content of Black life. On the basis of his technical

mastery of collage and his extension of the expressive possibilities of the medium alone, Romare Bearden seemed assured of a place in the history of twentieth-century painting.

If critics celebrated Bearden's technical innovations, however, they were also quick to note that collage for him was never an end in itself. The medium was always at the service of the message and Bearden's message is central to his art. As critic Hilton Kramer once wrote, "there is never any doubt that he does, indeed, *have* a subject and that the subject is not art itself. He just gives an emphatic priority to experience . . . over style. Yet, the style is distinctly modernist, and it serves its subject well."

But what was that experience? Collage was familiar to American critics and historians; Bearden's subject matter was not. Although American painters as diverse as John Singleton Copley, William Sidney Mount, Eastman Johnson, Winslow Homer, and Thomas Eakins all created major works using Black American life as their subject matter, Bearden's collages made use of a visual language seldom seen in American painting. His new world was populated by conjure women, trains, quitar players, birds, masked figures, winged creatures, and intense ritualistic activities: baptisms, women bathing, families eating together at their dinner tables, funerals, parades, night club scenes. The novelist Ralph Ellison referred to Bearden's images as "abiding rituals and ceremonies of affirmation." Bearden's own phrase, the "Prevalence of Ritual," underscored the continuity of a culture's ceremonies, marking the traditions and values that connect one generation to another, ceremonies that are universal, archetypal in their forms. Instead of painting mere genre scenes, the exterior landscape of events and people, Bearden chose to penetrate the interior of the lives he portrayed and, having pierced the skin of those day-to-day lives, connect his people and events to larger more universal themes. These connections were essential to his worldview. In 1972 he wrote, "In my work, if anything I seek connections so that my paintings can't be only what they appear to represent. People in a baptism in a Virginia stream are linked to John the Baptist, to ancient purification rites, and to their African heritage. I feel this continuation of ritual gives a dimension to the works so that the works are something other than mere designs." Italian Renaissance painting, West African sculpture, traditional Chinese painting, seventeenth-century Dutch genre scenes, as well as the Bible, the blues, Homer, and jazz found their way into Bearden's paintings as he looked for visual metaphors with which he could make his connections between Black culture and universal truths.

Visually and iconographically, then, the complexity Bearden brought to bear on Black American culture was unprecedented in the history of American art. Ralph Ellison summed it up when he wrote that Bearden's style permitted him to convey the "sharp breaks, leaps in consciousness, distortions, paradoxes, reversals, telescoping of time and Surreal blending of styles, values, hopes and dreams which characterize much of Negro American history." Bearden's acclaim was a recognition not only of his stylistic innovation, but of the depth and richness with which he offered

up Black American culture, opening a window onto an aspect of twentieth-century American culture which had been virtually invisible in the visual arts.

In response to his new work, the art world made all the legitimizing gestures typically associated with the acknowledgment of a major talent. Three major retrospectives of his work were organized in the space of fifteen years, including one at the standard-bearer of modern taste, the Museum of Modern Art. Major American museums acquired his works, although few in number. Art journals ran pieces featuring his works, most notably a cover story by the leading magazine, *ArtNews.* Commercially, Bearden's success was solid, if not extraordinary, and each of his one-man shows at the Cordier & Ekstrom Gallery was a sell-out, allowing him to quit his full-time job as a social worker in 1966. A shower of distinguished awards were bestowed on him, including New York's Mayor's Award of Honor for Art & Culture and, the year before his death, the prestigious President's Medal of Honor for Art & Culture.

Yet, in spite of all the accolades, in spite of the critical praise and his success in the marketplace, art historians have consistently overlooked his achievement. Major texts on post-World War II American art mention him only peripherally or omit him altogether. Museum exhibitions surveying American art of the 1960s and 1970s, the period when Bearden's collages quite literally burst upon the scene, rarely include him. Critics who abundantly praised his one-man gallery shows and museum retrospectives fail to mention him when speaking of American art in general. The omissions beg the question: Why did institutions and individuals who showered Bearden with lavish attention when dealing with him as an individual, fall silent or forgetful about his work when the subject of American art in general came up? It was this persistent neglect that motivated the Studio Museum in Harlem to become the fourth major American museum to mount a retrospective (the first since his death) of his work in twenty years and to send it, once again, all over the country. It would seem that, in Bearden's case, the retrospective functions in the manner of oral tradition, keeping his name and his art alive until the question is answered—what is Bearden's role in the history of American art?

Will Romare Bearden appear to be an anachronism in American art, his new forms an aberration, exotic and interesting, but ultimately not part of the central story of the art of this century? Or is his art, with its reliance on memory and history, its storytelling narrative technique, a nostalgic attempt to recreate the Black American past and, therefore, hopelessly old-fashioned and retrogressive? Many contemporary artists have chosen to do figurative work; but Bearden's work looks almost cheerful next to the existential and decaying figures of, say, a Francis Bacon or the disconnected figures of Alex Katz or Richard Diebenkorn. Is he, then, a maverick, breaking new ground before his time and heralding a new cultural pluralism in American art? If he did, in fact, discover new territory, what impact has his discovery had on the work of other artists?

The answers to those questions may be all of the above, depending on the vantage point one takes in an era which, like Bearden's collage surfaces themselves, is splintered and fragmented. In many ways his repudiation of mainstream art, a concept which implies a monolithic, cultural supremacy, his embrace within his art of cultural pluralism, and, at the same time, his fierce assertion of his own cultural identity and history may, in fact, be a metaphor for what has become of American art in the 1990s. Bearden's relentless search for an appropriate métier could be read as a quest for an art form that permitted him to define an American identity—that curiously elusive entity that grew more vague with the dissolution after World War II of the concept of a melting pot, and more compelling in the wake of a Civil Rights Movement that challenged the supremacy of any one cultural heritage.

What makes Bearden's art particularly difficult to grasp, however, is that even as his art points to the future, it also wholeheartedly embraces the past. His veering away from the direction of mainstream art is reminiscent of choices the European modernists made when they rebelled against the dictates of the Parisian salon, casting themselves outside of the then prevailing mainstream. Manet's *Déjeuner sur l'Herbe* in the 1863 *Salon des Réfusés*, and the work of the Impressionists, Post-Impressionists, Nabis, Symbolists, Fauves, Cubists, and so on who followed him signaled a sea change in the way art and life confronted one another. Indeed, it took history several decades to understand the value of the dizzying array of movements and artists of the late nineteenth and early twentieth century. In challenging the mainstream, European modernists admitted influences such as Japanese prints, West African sculpture, Peruvian death masks, pre-Columbian art, influences as diverse and inclusive and as challenging of a western artistic hegemony as those Bearden, many years later, admitted into his collage. By choosing collage, Bearden pointed to a past artistic rebellion in anticipation of a future one, and that may be key to his pivotal role in the history of twentieth-century American art.

Key also is Bearden's personal route to artistic rebellion. Along that route were critical points at which he felt that, given his cultural background, certain aesthetic choices were simply not possible for him. He was strongly influenced by the strong sense of community and the attitudes towards art that prevailed during the Depression years, the era during his youth in Harlem when Bearden first decided to become an artist. Because they are essential to understanding where he eventually landed, the details of his biography are worth summarizing. Bearden was born in 1912 in Charlotte, North Carolina. Shortly after his birth, his parents, Bessye and Howard, took him north to Harlem where Bearden's parents quickly became powerful and influential figures among the Harlem elite. A highly respected political organizer, and New York editor of the *Chicago Defender,* Bessye Bearden filled her home with writers and intellectuals such as W. E. B. DuBois, Paul Robeson, and Langston Hughes, as well as painters such as Aaron Douglas and Charles Alston—all of them prime movers in what would come to be known as the Harlem Renaissance. The

jazz musicians too were part of the Beardens' circle—Fats Waller, Andy Razaf, Duke Ellington. Bearden spent his summers in Charlotte with his paternal grandparents and great-grandparents. During his high school years he lived in Pittsburgh, where his maternal grandmother owned a boarding house. Bearden's memories of Charlotte and Pittsburgh are vivid. He recalls the men and women working in the fields in Charlotte and the blazing beauty of the Carolina countryside in the summer. Of Pittsburgh Bearden remembers watching the men, the recent migrants from the South, return daily from the steel mills, their backs scorched from the heat of the furnaces. Harlem, Charlotte, and Pittsburgh: these were the territories not only of Bearden's childhood, but of a whole period of the African-American experience. Much later, as this world passed away, Bearden began to reconstruct it in his collages.

By the time Bearden chose art as a vocation, Harlem, in spite of the Depression, boasted a thriving community of visual artists, many of whom, supported by the WPA, were encouraged to pursue art as a full-time career. Working on public art projects, teaching or working on WPA easel projects, these artists also benefited from a network of exhibiting spaces: a federally supported art center on West 125th Street; sculptor Augusta Savage's "art garage," in which this young Black artist took it upon herself to teach budding artists; an exhibiting space maintained by Ad Bates, a dancer, on 306 West 141st Street; and local libraries, the YMCA, and countless Harlem living rooms and parlors. Bearden, whose influential parents supported him in those early years, did not qualify for the WPA rolls but he was always active nonetheless in the artistic community. He was among the artists who organized the Harlem Artists Guild, and he wrote articles for *Opportunity*, the magazine of the Urban League, on Black American art and social issues. His only formal instruction and his first contact with the downtown art community occurred during this period when he studied with the German painter George Grosz at the Art Students League. Bearden came to Grosz with the desire to get a social message into his art, and Grosz in turn introduced Bearden to the work of Daumier, Goya, and Käthe Kollwitz.

Harlem during the 1930s was the venue and crucible for jazz, the most vital avant-garde art form to come out of America in the first half of the twentieth century. Bearden and his artist friends were jazz devotees and regularly made the rounds of nightclubs and cabarets and the illegal speakeasies that flourished during Prohibition and attracted racially mixed audiences from all over the world. Bearden was initiated, so to speak, as an artist into a closely knit community where communal values and expectations were at the core of his aesthetic experience.

After World War II, all of that changed. With the war came the demise of the WPA, the dissolution of the patronage system that supported Black American artists, and the slow decay of American inner cities in the North. After the repeal of Prohibition, the underground network of night spots where jazz flourished no longer attracted patrons who lived

outside of Harlem. The musicians' loss of their patronage and the visual artists' loss of federal support dealt the uptown artistic community a severe blow. Many artists left, leaving Bearden without the close-knit group he had enjoyed before the war. His mother's death in 1943 was yet another loss, breaking apart the tight cocoon of community he had enjoyed as a young adult.

If Harlem was changing, the mood of the country was changing as well. During the Depression, economic disaster hit all Americans, and an egalitarian spirit, a spirit that also permeated the art community, created an unusual camaraderie among artists, helped by a democratic system of federal patronage. After the war the ideological divisions of the Cold War cast suspicion on the left-wing ideas popular during the Depression, and the hostilities and paranoia of the McCarthy years led to the outright blacklisting and silencing of some artists, most notably, among Bearden's heroes, the actor, singer, and activist, Paul Robeson. Among visual artists, the reaction was to turn to private, individual expression and to make no attempt to address larger social issues. It was a direction that would deeply discomfort a young artist who thought of art as an expression of collective values.

After the war, with the emergence of private galleries and of the New York art world, a less democratic attitude prevailed. When federal patronage disappeared, many Black American artists found themselves without a means of support. Some like Norman Lewis and Jacob Lawrence did find galleries. Some, like Beauford Delaney, Sam Middleton, and Walter Williams, left the country. Bearden was fortunate in that immediately after the war he found himself in the enviable position of being one of the few Black artists to be part of the newly developing downtown art scene. He was a member of the Samuel Kootz gallery, a leading modernist forum that included the painters who would pioneer Abstract Expressionism. Adolph Gottlieb, William Baziotes, Robert Motherwell, Carl Holty, and Byron Browne were all part of the Kootz stable and were among the American painters who, with Jackson Pollock, Willem de Kooning, and Franz Kline, created the so-called "Triumph of American Painting."

In his close association with the Abstract Expressionists Bearden first sensed the depth of his differentness, his alienation from the direction of avant-garde American art. Abstract Expressionism as Bearden understood it was less a movement and more a shared attitude towards art, a turning away from the socially conscious art of the Depression years. Those artists who formed the nucleus of this American avant-garde celebrated art as a private, individual expression. Stylistically, many rejected easel paintings in favor of the large unstretched canvas, accepted nonobjective abstraction and the Surrealist heritage that championed the compelling force of the imagination, dreams, and myth as opposed to observed reality. Based on biblical themes and literary works as diverse as those of García Lorca, Rabelais, and Homer, Bearden's small, Cubist-

inspired figurative oils of the period 1942 to 1949 were antithetical to the "action" paintings of Pollock or the color-field exercises of Rothko or Newman.

At this point in his career he began to write lengthy treatises on the nature of art in his letters and journals. As his ideas started to crystallize, they did so in opposition to the underlying assumptions of the Abstract Expressionist aesthetic. For one, he rejected the avid individualism of the Expressionists, their growing insistence on a private rather than public worldview. In a letter to the artist Carl Holty, Bearden wrote, "in a sense this isolation, in fact, as well as in spirit, makes our own tasks really difficult. For we don't have the benefit of a strong group consciousness and contributions on lower levels that many great artists of former times enjoyed." Bearden recognized that the emphasis on a private worldview was not peculiar to American painters, observing, again in a letter to Holty, that it is the plight of the modern artist in general to be, in his words, "a kind of specialist, working on a particular and individual statement. It is with the utmost difficulty that even the most initiated read Joyce's *Finnegan's Wake* . . ." Bearden deeply believed that the artist was set adrift, his work unmoored, when disconnected from the community. He went on to write, "I feel that an artist and his creations are enhanced when he has the added emphasis and 'vision' of his particular society working with him."

In addition to the loss of community, Bearden was troubled, too, by Abstract Expressionism's failure, in his eyes, to find some broader philosophical content. The broader context of Bearden's paintings of the 1950s were specific literary texts and the history and heritage those texts brought to bear on his visual interpretations of them. Bearden's use of literature was influenced by the art of the past. He wrote:

> When Delacroix began to transcribe his romantic vision, he had the heritage of Herder, Schelling, Schiller and all the French Romanticists who were of his time. So when I look at Stamos, Baziotes and the rest, I wonder what point their work has, and to what end does it drive.

Although many of the Abstract Expressionists—William Baziotes, David Hale, Clyfford Still, Mark Rothko, and Barnett Newman—founded a school to investigate "the subjects of the modern artist," Bearden could see no underlying rationale for their work and soon drifted apart from the group altogether.

During his years with the Kootz gallery Bearden sought artistic alliances with a number of artists outside of the Kootz stable. He maintained an active correspondence with the abstract painter Carl Holty (a onetime Kootz artist) and Walter Quirt, a Surrealist painter, but perhaps even more important to his developing aesthetic was his association with the American painter Stuart Davis. Stuart Davis, like Edward Hopper and Jacob Lawrence, had created in his painting an indigenous American iconography that gave visual definition to the pulse and tempo of a particular aspect of American life. Davis, who had developed an elaborate

theory of color, had turned to jazz, particularly the piano of Earl "Fatha" Hines, in looking for a structural basis for his painting. Bearden credits Davis as the artist who encouraged him to think seriously about this music that had been so much a part of his coming of age in Harlem. In his return to memory as a source for his art and in his exploration of identity, Bearden developed a compositional approach to college that was inspired by jazz. He also regarded the history of its development as a metaphor for the permutations of identity of the African American. What this period in Bearden's life illustrates is the ultimate disaffection of artists whose aesthetic choices don't fit. In an authoritative or homogeneous culture, the issue perhaps is not particularly urgent. But given the values of pluralism, the domination of a single mainstream is a contradiction in terms.

Bearden's acute sense of alienation would force him to leave the United States in 1951 to look for inspiration in Paris, the focal point of twentieth-century modernism. Although his stay in Paris proved to be a great opportunity to see art and meet some of the great masters, such as Brancusi and Picasso, Paris was not conducive to painting and Bearden returned to the United States without having painted at all. After his return, as his alienation grew, Bearden gave up painting altogether and took up songwriting. His turmoil over his direction as an artist ran deep, however, and he suffered a complete breakdown in the mid-fifties. In 1954, he married Nanette Rohan, a dancer and artist in her own right, and began a slow, tentative return to painting by copying Western painters. Starting with Giotto and Duccio, he worked his way up to Rembrandt, Delacroix, and, eventually, Picasso and Matisse. Bearden was like an archaeologist excavating the past, trying to discern patterns of truth. His intensive studies gave him a new understanding of painting, a knowledge he displayed in the book he co-authored with the painter Carl Holty, entitled *The Painter's Mind.* During this period of study, Bearden painted his large abstract oils and began to experiment with collage. In 1964, events outside of his studio compelled him to change his art dramatically, and galvanized his thoughts on art, race, and his American identity.

The elusive sense of community group consciousness which Bearden seemed to feel was necessary to produce good art, gathered around him with the ferocity of a brewing storm in the early 1960s. As the news of bus boycotts and student sit-ins at lunch counters in the South reached the North, it inspired Bearden in much the same way he had been inspired during the 1930s; he organized artists. He formed the group Spiral, an organization of twelve Black artists whose stated purpose was "to examine the plight of the Black American artist in America." During one of their meetings, Bearden encouraged the artists, who met on a regular basis, to produce a group work. He proposed collage as a means of working collaboratively but the group wasn't interested. Bearden continued his explorations on his own.

The summer he worked on his first collage pieces was the summer that

Harlem, his childhood community, erupted like communities all over the country into civil insurrection. The distortions, energy, and vivid images of Bearden's first collages, black and white photographic blowups, were the seismographic readings of the turbulence within the inner cities. For Bearden the cynical detachment of Pop Art, the unemotional cool of minimalism, simply were not an option for him. Moreover, when Bearden opened the door—not only to the force of contemporary events but to the rush of memory and potent images from his past—he closed the door forever to the obsessive "art for art's sake" purism that had dominated American mainstream art up until that point. And it was in connecting his personal memories to large archetypal themes in painting and in literature that he assumed a public rather than private aesthetic.

Bearden was at the forefront, too, of another important cultural movement, the establishment of places for the exhibition and support of so-called "alternative" visions. If the years immediately after World War II witnessed the coming of age of the great modernist institutions—the Museum of Modern Art, the Whitney, the Guggenheim—the years during the Civil Rights Movement witnessed the first serious challenge of these mainstream museums by a host of alternative spaces that took root in out-of-the-way lofts and storefronts. Bearden was personally involved in the founding and early support of at least three of them—the Storefront Museum, Cinque Gallery, and the Studio Museum in Harlem. In the 1960s and 1970s in New York City community institutions sprang up which supported not only Black American art but all kinds of cultural expressions the mainstream museums for one reason or another would not accommodate: the New Museum, the Institute for Contemporary Art/P.S. 1, the Bronx Museum of the Arts, the Caribbean Cultural Center, El Museo del Barrio, Artists Space, the Alternative Museum, the Asian-American Institute, and so on. These young organizations recognized the value in creating the kind of public presence that the art of those who challenged the mainstream needed for their survival.

The new world Bearden wanted to create out of his "Negro experience" was different from mainstream art in one other significant regard. His new art was value-laden. His paintings had what Susi Gablik would call a "moral center." Throughout his collage works there are references to good and evil. The conjure woman can cast spells; she can harm or she can heal. There are heroes and heroines. Maudell Sleet is an admirable toiler in the fields, and work, hard labor, is celebrated as an ennobling activity and fundamental to Black American survival. Women often embody moral judgements. *She-Ba* is regal; the nude woman in the garden is a dangerous temptress. In the urban scenes, on the city streets, there is violence that is destructive, yet there is also redemption and a transforming vision that allows hope. Like the sacred rituals that bring to life West African masks (masks that appear over and over in Bearden's work), or the stained-glass-like quality of his collages, which calls to mind the scriptural lessons displayed in the windows of a Gothic cathedral, Bearden's collages depend on an underlying moral view of the world.

Bearden's willingness to take a moral position reflected what would become a growing disaffection among younger artists with the disconnectedness of post-World War II art. Even the most cursory look back at the 1980s confirms this. The most important work of public art, Maya Linn's Vietnam War memorial, quietly condemns the waste of individual human life without diminishing the heroism of the men and women who sacrificed their lives. The lynch fragments of Melvin Edwards—pieces constructed as early as 1963—are harsh judgements against racial violence and at the same time herald a transcendental attitude towards that violence. More recently, David Wojnarowicz' condemnation of the official repression of the information on AIDS, or Maria Brito-Avellana's child carved like a santeria out of a crib, are examples of works that rest firmly on the artists' cultural traditions and values. Clearly, Bearden set a tone that would prevail at the *fin de siécle*.

Works of this type require an art history very different from what we have had in the past for contemporary art. Understanding the works of artists who fill their art with history, biography, cultural values, and traditions requires much more than the descriptive rhapsodizing required for work with only a visual content. Bearden's work signaled the need for patient iconographic study; his personal biography, the history of the Black American, the aesthetic traditions on which he draws, all this knowledge is a requirement, as well as the willingness to believe that art in the twentieth century can have a moral center. In many ways this willingness to look at the visual arts as moral humanistic study may be the greatest challenge the work poses.

Will historians be up to the task? History, like the art itself, will probably have to experience an explosive redefinition. Globalism is unavoidable in the twentieth century and, given that fact, a mainstream is obsolete. If that is indeed the case the challenge for the new historians will be, as it was with Bearden's collages, to define its own dictionary, its own critical language and its own self-definition.

MEMORY AND METAPHOR:
THE ART OF ROMARE BEARDEN, 1940–1987

Sharon F. Patton
Chief Curator
The Studio Museum in Harlem

Romare Bearden (1912–1988) commemorated life through art.[1] He depicted the cycle of life and the rituals and social customs essential to it in twentieth-century America. Spiritual ceremonies, baptism and burial, daily life and work in Black America were Bearden's subject and at the heart of his aesthetic.

In his paintings, ordinary tasks and acts sometimes aquire mythic resonance and are transformed into symbols. A young woman bathing in a tin tub, for example, becomes a symbol for the ritual of purification; a young son greeting his mother, for the return of the prodigal son; and mother and child become the Virgin Mary and Christ. Bearden's biblical and mythic subjects, in turn, such as scenes from the New Testament or the *Iliad*, are given the immediacy of the everyday in his work.

The visual eloquence of Bearden's art recalled the prose of African-American life as he reconstructed his own life's history and the culture of African Americans. It is his life with his paternal grandparents in Mecklenburg County, North Carolina, or later with his paternal grandmother in Baltimore, Maryland; it is his adolescence with his maternal grandmother in Pittsburgh, Pennsylvania and his youth and adulthood in Harlem, New York City.

Bearden's journeys are imagined and realized, both spatially and temporally. There are the places one leaves, and those to which one returns. For Bearden, it is Harlem, Pittsburgh, St. Martin, and, especially, Charlotte. There are the brothels of Storyville in New Orleans or Pittsburgh, the revival meetings in Charlotte, the sermons of Baptist churches in Harlem, the dining rooms or front porches of homes in North Carolina and the stoops and corners in Harlem. Bearden juxtaposed rural fields and gardens and urban streets and tenements, depicting social interaction among African Americans reminiscent of the bustling public activity in any West African or Caribbean market. He also juxtaposed blues singers and musicians and those of "hot" jazz. Anonymous, yet not forgotten, banjo players, guitarists, and fiddlers and singers share in the musical milieu of Clarence "Fats" Waller, Duke Ellington, Earl "Fatha" Hines, Bessie Smith, Alberta Hunter, and Billie Holiday.

"Memory and Metaphor: The Art of Romare Bearden, 1940–1987" is an

exhibition of paintings dating from 1940 to 1987. Approximately 140 paintings (tempera, watercolor or gouache on paper, oil on canvas, and collage and mixed media) highlight Bearden's artistic exploration, change, and maturation.

Bearden was a prolific artist. Extant works number in the hundreds. Known primarily as a collagist, Bearden used various techniques and media: prints (intaglio, color etching, lithography, and silkscreen); drawings (graphite, charcoal, ink); paintings (oil, acrylic, watercolor, gouache); collage.

Bearden was inquisitive, always investigating new sources, new materials, and techniques for his art. He did not abide by the traditional categories of fine art, experimenting throughout his career with various media.

During his career, Bearden changed his focus, from the social realism of the 1930s to the modernism of the 1940s and 1950s. He revived the collage technique (a medium associated with Dada and Surrealism of the early twentieth century), brought it to an unsurpassed level of technical sophistication, and made it his artistic signature (see p. 37).

In regard to his work, Bearden said he put one layer over another. Similarly, his life reflected layers of aesthetic experiences, in both the United States and Europe. There were meetings and discussions with fellow American artists, such as Stuart Davis, Carl Holty, William Baziotes, Walter Quirt, Charles Alston, Ernest Crichlow, Hale Woodruff, and Norman Lewis. In Paris he met Georges Braque, Constantin Brancusi, and Jean Hélion. And he absorbed world cultures through literature, art, and music, from which he created his own vision.

Bearden studied, often at firsthand, Byzantine mosaics; fifteenth and sixteenth century Italian paintings as in the works by Duccio, Cimabue, Giotto, Titian and Veronese; seventeenth century Dutch genre paintings as in the works of Vermeer, Jan Steen, de Hooch and the works of Rembrandt; late nineteenth century paintings of Manet and Cezanne; twentieth century painting by Matisse, Picasso, Mondrian; African art; Chinese landscape painting and Japanese painting and prints. Throughout his career, Bearden referred to them as he made his art.

From 1940 to 1965, Bearden set the aesthetic character of his art. For the first few years of his career, between 1940 and 1942, he painted African-American social genre, primarily of the South. Between 1945 and 1948, modernism, when he painted linear abstract, figural works inspired by the Bible, Greek myth, and literature. Abstract expressionism was his style between 1955 and 1962. Then, in 1964, he began making photomontages and photostats of his works, which soon developed into his almost exclusive use of collage as a medium and marked a return to the use of the figure in his art, a style he would never relinquish.

As Bearden's work developed over the next twenty years, he attained the status of master painter. Paraphrasing Bearden, artists learn to accept the limitation of both their medium and themselves and they find a true relationship with their art. It is a moment when the inner world of vision

and imagination marries with the pictorial world, and the works reflect the effort and vision of the artists. The paintings produced during these years reflected the artistic experiences and influences of the previous twenty-one years. One sees the figurative and cubistic styles of the early and mid-1940s, the Abstract Expressionism of the 1950s and the figurative collage of the 1960s.

Search and Formation: Paintings from 1940 to 1965

The composition—structure, space, and line—and restricted color of Bearden's paintings dating from the early to mid-1940s developed from his artistic explorations of the 1930s. During those years, Bearden was an editorial cartoonist, met American (particularly African-American) artists, studied at the Art Students League, analyzed art masterpieces, became familiar with art theory and history, and formed his own ideas about the role of art and the artist in society.

Bearden's interest in drawing began during his childhood friendship with Eugene Bailey in Pittsburgh, where Bearden spent summers with his maternal grandmother in the mid-1920s. Bearden, who marveled at Bailey's drawings, drew until his friend's death in 1925 (later immortalized in a painting, *Farewell Eugene*, plate XIX).[2] Not until the 1930s is there evidence of Bearden's renewed interest in art. Around this time, he met Elmer Simms Campbell, one of the leading cartoonists in the United States, known for his work in *Esquire* and the *New Yorker*. Apparently lured by Campbell's success, and his own interest in drawing, Bearden did editorial drawings for the *Baltimore Afro-American* between 1931 and 1935 (fig. 1). He also worked for *Colliers* and the *Saturday Evening Post*.

Romare Bearden's formative years as an artist were spent in Harlem, in uptown New York City. Beginning in 1933, while a student at New York University, where he earned a degree in mathematics in 1935, he drew cartoons for the university's humor magazine, *Medley*.[3]

In 1935, still undecided about becoming a professional artist, he attended a meeting of African-American artists at the Harlem YMCA on 135th street, the beginnings of the Harlem Artists Guild. Although he was familiar with African-American art history and knew a few artists, including his cousin Charles "Spinky" Alston, Bearden was nonetheless surprised at seeing so many artists there—approximately fifty. He realized that he was not alone, and Bearden confidently embarked upon a career as a professional artist. After that meeting, called to identify other African-American artists in the community and to organize artists formally, he appreciated the Works Progress Administration (WPA), which enabled African-American artists to develop professionally. Many of the attending artists, including Alston, Aaron Douglas, and Norman Lewis, were employed by the WPA. Bearden later recalled, "I found that the WPA, even at the worst time of the Depression, gave artists a salary and

Fig. 1. *Beginning to Loom Larger and Larger on the Horizon.* ca. 1934. (The Museum of Modern Art.) Gift of Mr. and Mrs. George Elcaness. 24 × 17³/₄″. Graphite, ink, gouache on paper

materials to work with. It gave minority artists what they could never have afforded otherwise."[4]

Bearden became part of an informal group of Black artists in Harlem, the "306 Group." Named after the studio lofts at 306 West 141st Street, the group met at Alston's loft, which he shared with Henry "Mike" Bannarn. Some of this group also belonged to the Harlem Artists Guild, formed in 1935.[5] Soon, writers, poets, visual and performing artists from other parts of New York City and from diverse cultural and ethnic backgrounds, including artists from Western Europe, converged at 306. It was the American equivalent of a Parisian art salon. There, among the groups of writers, musicians, and painters, Bearden met Langston Hughes, Claude McKay, William Saroyan, Carl Van Vechten, William Steig, Ralph Ellison, Jack Carter; artists Francisco Lord, Vertis Hayes, Norman Lewis, Jacob Lawrence, Ronald Joseph, Gwendolyn Bennett, Augusta Savage, Aaron Douglas, O. Richard Reid, Frederick Coleman, Ernest Crichlow, Robert Blackburn; musicians and lyricists Sammy Steward, John Hammond, Andy Razaf; and dancer Addison Bates. The friends Bearden made at 306 were instrumental in his artistic development and career. Bates introduced Bearden to Walter Quirt (who later introduced Bearden to Stuart Davis), Paul Burlin, Alonzo Hauser, and Manuel Telegian. McKay introduced Bearden to Charles C. Seifert, "Professor" Seifert as he was called by his friends, who had a vast library on African art and history and guided Bearden and other aspiring African-American artists in learning about their heritage. Bearden's friend and fellow artist Ernest Crichlow recalled that between 1935 and

21

1941 "there was a closeness, a sharing within the African-American artistic community in Harlem that Romy and I talked about a lot."[6]

In 1936, after about three years' experience as an editorial cartoonist, Bearden enrolled with Eastman Campbell for evening classes at New York's Art Students League. There, he met and studied under the German Expressionist George Grosz, attracted, most likely, by Grosz's style and reputation as a political cartoonist. Grosz's sure, expressive lines delineating realistic figures, and his images of everyday life in World War I Germany had a strong influence on Bearden, and he began to appreciate the artistic possibilities of his own American, specifically African-American, subject matter. Further encouraged by studying the drawings of Honoré Daumier, Jean Louis Forain, and Käthe Kollwitz, Bearden was inspired to continue the expressive line rendering of the figure seen in his editorial drawings (fig. 2). At the League, Bearden recalled, Grosz led him "to study composition, through the analysis of Brueghel and the great Dutch masters and . . . in the process of refining my draftsmanship initiated me into the magic world of Ingres, Dürer, Holbein and Poussin."[7] Now, Bearden regarded himself as an artist.

A year and a half later, Bearden left the Art Students League, but he continued to paint part-time while working at the New York City Department of Social Services. In 1940, still working, he took a studio in 33 West 125th Street, the same building where Jacob Lawrence, from whom Bearden learned about the space, and Claude McKay had their studios. There he began to paint regularly, using brown paper and gouache.

1940–1948
In May of 1940, Addison Bates gave Bearden his first solo exhibition. According to Bearden,

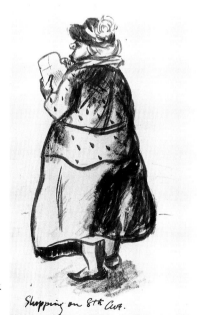

Fig. 2. *Shopping on 8th Avenue* (sketch). ca. 1937. (Schomburg Center for Research in Black Culture, The New York Public Library.) 6³/₄ × 3¹⁵/₁₆″ Ink and conte on paper. *Photo: Lee White.*

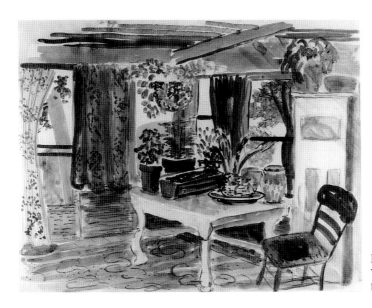

Fig. 3. *Interior.* 1939. (Collection the Carl Van Vechten Gallery of Fine Arts, Fisk University, Nashville, Tennessee.)

My first show—my very first show—was not in a fancy downtown gallery. It was given to me by Ad Bates up in Harlem. 'Ad' was one of the finest wood craftsmen we've ever had. He had a loft workshop at 306 West 141st Street where he presented my show six months after he had shown Jacob Lawrence.[8]

The exhibition, "Romare Bearden, oil, gouaches, water colors and drawings, 1937–1940," displayed twenty-four mostly student works (eighteen of which were paintings) including *Interior* (fig. 3).

The exhibitions at 306 exemplified the objectives of the Harlem Artists Guild. African-American artists were identifying who were important among them in a Black community that was committed to and recognized African-American artists. Crichlow remembers New York artists from other parts of the country and from Europe coming to the gallery openings. For the artistic community, 306 was the place to be.

By the 1940s, Bearden had become a Social Realist painter and draughtsman. And, like Ben Shahn, George Grosz, William Gropper, Alston, Archibald Motley, Lawrence, and the Mexican muralists, Diego Rivera, José Orozco and David Siqueiros, he was interested in portraying the human figure and the human condition.

Two Women in a Landscape (ca. 1941, fig. 5) typifies Bearden's style during the early 1940s. Two three-quarter figures dominate the shallow spaces of the landscape and gaze stoically and majestically at the viewer. Because they are placed near the frontal spatial plane and the high horizon line, they become monumental. The simple modeling of form, the planar, schematic surfaces, and the emphatic facial contour make the women appear sculptural. The subdued, earthy browns, blues, greens, and red underscore the simple volumes. One is reminded of traditional African sculpture and the muralist styles of Tamayo, Rivera, or Orozco, whom Bearden greatly admired.

Bearden's interest in spiritual symbols is evident in *Two Women in a Landscape* and other paintings of similar style from the same period. In one, the biblical meeting between Mary and Anne is represented as an encounter between two southern Black women. There is an element of religiosity in *Two Women in a Landscape* that suggests the Annunciation, the hand positions and the Christian iconic gestures recalling Byzantine and fourteenth-century Italian panel paintings and frescoes.

In retrospect, this and other realistic paintings of this period were the foundation for the collage paintings of the late 1960s and later. Folk musicians, a woman holding a child in her arms, a man serenading a woman, two women greeting each other, and a seated woman are recurring motifs in Bearden's oeuvre (figs. 5, 7, 13, 15, and plate IV). Their configuration would be only slightly altered by the influence of other art and artists over the next forty years (figs. 30, 34, 35, 36, 58 and plates IX, X, XII, XVIII). They became and remained the protagonists of Bearden's paintings, his personal icons.

By 1940, Bearden had clear ideas about the role of an artist. In 1934, in an essay, "The Negro Artist and Modern Art," Bearden criticized many contemporary African-American artists' works as "hackeneyed and uninspired, and only mere rehashings from the work of any artist that might have influenced him." He felt philanthropic societies and foundations were at fault, especially the Harmon Foundation because, by not imposing high critical standards in their exhibitions and encouraging a "racial identity" (usually translated as primitivism) in art, they encouraged mediocrity in the visual arts. Bearden also felt that the lack of substantive art criticism about African American art and of a "social philosophy or definite ideology," hindered the development of the African-American artist. Although, he was not sure then what was an appropriate philosophy or ideology, Bearden identified two criteria for determining good, modern artists. They "substituted for mere photographic realism, a search for inner truths," and made art based on their own experiences, steeped in the traditions of their society,[9] an opinion he held and practised throughout his career. Bearden's comments were more personal and general in an essay he wrote for the 306 exhibition pamphlet:

> I believe the function of the artist is to find ways of communicating, in sensible, sensuous terms, those experiences which do not find adequate expression in the daily round of living and for which, therefore, no ready-made means of communication exists.
>
> I believe that art is an expression of what people feel and want. In order for a painting to be 'good' two things are necessary: that there be a communion of belief and desire between artist and spectator; that the artist be able to see and say something that enriches the fund of communicable feeling and the medium for expressing it.

Romare Bearden began establishing his artistic reputation in the early 1940s. An opportune moment came when fellow artist William H. Johnson introduced him to Caresse Crosby, a well-known patron of Salvador

Fig. 4. *Anderson's Materials.* ca. 1939. (Collection The Amistad Research Center, New Orleans, Louisiana. *Photo: Jackson Hill, Southern Lights Photography.*)

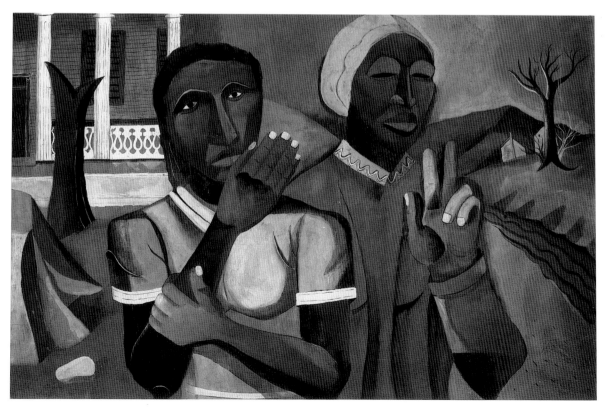

Fig. 5. *Two Women in a Landscape.* ca. 1941. (Collection Aida Bearden Winters, New York. *Photo: Dawoud Bey.*)

25

Dali and other modern artists who, with her husband, founded and published *Black Sun Press,* an avant-garde Parisian journal of illustrated essays. Crosby had noticed Bearden's work, more than likely in the 1941 group exhibition "Contemporary Negro Art" (McMillen, Inc.), which showed two works by Bearden, or in "American Negro Art, 19th & 20th Centuries" an exhibit held in 1942 at the Downtown Gallery in which one of his works appeared.

In 1944, Crosby organized two exhibitions in the G Place Gallery, in Washington, D.C. The first was a solo exhibit in February, "Ten Hierographic Paintings by Sgt. Romare Bearden." At a group exhibition that followed in June, "New Names in American Art" (first held in the Baltimore Museum of Art), one of Bearden's paintings was shown. Art historian James Porter and philosopher Alain Locke, noted African-American scholars, wrote an essay, "Notes on Romare Bearden" and the "Foreword," respectively, for the two exhibition brochures. Porter observed,

[an artist's] creations are not life, but a revelation of life—its meaningful essence. How profoundly Romare Bearden understands this limitation of art and how effectually he makes use of it is borne out by this exhibition. His work contains that balance between the conceptual and the expressive which seems to point the way towards a new and influential integration of art and social interest, establishing an important crux of artistic form and human quality which cannot be ignored. When one looks at the most characteristic productions of Sargeant Bearden one is reminded of the definition Wordsworth has given to poetry; namely, that it take its origin from emotion recollected in tranquility. Underlying the epic emotionalism of this artist is a superb gravity of style which is best suited to its subjects. Bearden, like the stained glass makers of olden time, compresses the story within a crucial mold of lines and prismatic colors. Indeed, his use of forms shows an excellent education in the history of art as well as a remarkable power of adapting the suggestions of various primitive geometric idioms to his special requirements. His use of color heightens the emotional give and take between the spectator and the picture. After examining his work one goes one's way with a definite sense of the communicableness of thought in the media of art. Bearden offers us the privilege of learning truth through the congenial offices of color and design.

By 1944, Bearden had turned his attention away from the Social Realism of the 1930s with its focus on American genre painting. Now, he was inclined toward the use of flat, geometric, and mostly abstract design and blocks of color. His paintings included figural elements, such as heads and hands, sometimes used in silhouette or in schematic rhythmic designs. In *Two Figures* (ca. 1945, plate III), a work stylistically similar to *Lovers* (1944), which was displayed at the G Place Gallery, interlocking geometric shapes, each defining areas of contrasting hues and values, are combined with decorative patterns of dots, staccato strokes, or squiggly lines.

However, there are two stylistic variations in the work of the 1940s.

Forms are defined either by drawn black lines or by stark contrasts of color and value. Color may be translucent or opaque. Bearden's paintings of the mid-1940s look either like medieval stained glass windows or like the synthetic Cubism of Georges Braque of the late 1920s (figs. 6–10, 12, plate III).

> I wanted at that time to discover a personal way of expression that might be called new. I had nothing, of course, against representational images, but the demand, the direction of the sign factors in my paintings were completely obliterating the representational image. I was trying to find out what was in me that was common to other men. If I remember, it was hard to do and realize.[10]

In 1944, Caresse Crosby introduced Bearden to Samuel M. Kootz, a New York art dealer who represented many of the leading American abstractionists of the time—Adolph Gottlieb, William Baziotes, Robert Motherwell, George Byron Browne, and Carl Holty.

Kootz had asked to see some oils as examples of Bearden's work, which Bearden quickly made for the occasion (Bearden was working then mostly in gouache). Bearden's technique was unusual. As Bearden later described it, "When I started to paint in oil, I simply wanted to extend what I had done in watercolor. To do so, I had the initial sketch enlarged as a photostat, traced it onto a gessoed panel and, with thinned color, completed the oil as if it were indeed a watercolor."[11] He then used a speedball pen to insert the outlines and accents of the figures and shapes. These paintings duplicated the visual effect of watercolors, a technique he would use often (figs. 6, 8,).

Immediately impressed by the young artist's works, Kootz arranged to exhibit them at his gallery on 57th Street. "The Passion of Christ" (October 1945) was the first of three Bearden exhibitions held at the Kootz Gallery; "Bearden" followed in 1946, and "New Paintings by Bearden" in 1947. "The Passion of Christ" was important on two counts: it was Bearden's first solo exhibition in a mainstream gallery, and it established him as an important abstract painter.

The paintings depicting biblical scenes from the New Testament were a critical success. Within the first two weeks, twenty out of twenty-four paintings had been sold (figs. 6, 7, 8). The Museum of Modern Art bought *He is Arisen* (plate I), the first museum to purchase Bearden's work. Although several watercolors from "The Passion of Christ" series had been shown in an exhibition of the same title earlier in June at G Place Gallery, the Kootz exhibition garnered more publicity. Reviewers extolled Bearden's works. Carl Van Vechten, the novelist and photographer who actively participated in the Harlem art scene in the 1920s and 1930s, upon seeing the paintings, referred to Bearden as "the Negro Rouault." From 1945 on, Bearden became increasingly successful. For the next eleven years or so, his works were exhibited nationally in group exhibitions, most notably the biannual show at the Whitney Museum of American Art.

Fig. 7. *Madonnna and Child.* 1945. (Collection Bryn
Mawr College, Bryn Mawr, Pennsylvania.)

Fig. 6. *Resurrection.* 1945. (Collection Duke
Ellington Family, Ruth Ellington Boatwright
and Steven and Allison James, New York. *Photo:
Dawoud Bey.*)

Fig. 8. *Madonnna and Child.* ca. 1945. (Collection
Morgan and Marvin Smith, New York. *Photo:
Dawoud Bey.*)

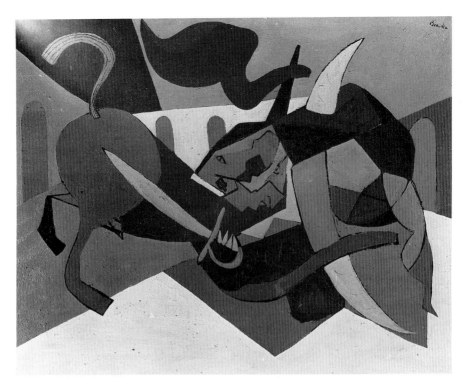

Fig. 9. *Five in the Afternoon.* 1946. (University of Oklahoma Museum of Art, Norman, Oklahoma.)

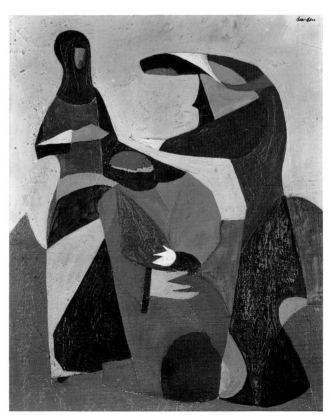

Fig. 10. *Even the Sea Dies.* 1946. (Collection Morgan and Marvin Smith, New York. *Photo: Dawoud Bey.*)

In an artist's statement written for the G Place Gallery's exhibition pamphlet, Bearden wrote:

> this myth (of the life of Christ) is one of the greatest, perhaps the greatest, expression of man's humanism. In none of the other mythological or religious concepts is this sheer human quality so poignantly expressed. The concept supercedes reality and the usual conformist interpretations, so that it makes little difference as to the factual nature of the story, or even whether or not such a man as Christ actually existed. What is important, is that the idea has lived in them.
>
> The power of the Christ story, its universal recognition, and the general familiarity of everyone with its events, make it unnecessary for me to dwell on its literary aspects—nor is that the problem of the artist. Rather, it seems to me, it finds new plastic equivalents and standards of aesthetic and psychological values. I am not akin to the purists who disclaim all subject matter in art; however, I do not believe the delineation of subject should constitute an end in itself. I have used as the motive-force of my paintings certain incidents as I have read them in the Chapters of Mark and Matthew. But beyond these surface considerations, my concern is with those universals that must be digested by the mind and cannot be merely seen by the eye.

In seeking to find "those universals" of the human condition, Bearden often turned to both ancient and contemporary literature. In the late 1940s and subsequent years, Federico García Lorca, Rabelais, and Homer were artistic inspirations for him. Like many of the early Abstractionists in New York in the mid-1940s, Bearden sought to convey a humanist message in his paintings, drawing upon history and myth.[12]

Paintings in the next exhibition at the Kootz Gallery, "Bearden," were inspired by García Lorca's "Lament for Ignacio Sanchez Mejias" (1935) and were poignant abstractions of this mournful poem. Two subjects, the bullfighter, as in *Five in the Afternoon* (fig. 9) and *What a Great Torero in the Ring* (fig.11), and mourning, as in *He Sleeps Endlessly* (also titled) *You Are Dead Forever,* plate II) and *Even the Sea Dies* (fig. 10), are representative of the presence and inevitability of death. Rabelais' satirical masterpiece *Gargantua and Pantagruel* (Chap. VI, Bk.1) was the literary source for Bearden's work in the Kootz exhibition "New Paintings by Bearden." In the series, Bearden translates the often ribald humor of Rabelais' work into an embrace of life seen in the ritual of drink. The overall style of the paintings in these early exhibits and that of *Iliad,* another literary series of sixteen paintings shown at Niveau Gallery, New York in 1948, are similar.

From around 1944, Bearden began increasingly emphasizing line (figs. 11–15) to map movement and placement. In these works, line not only defines contour, but indicates a figure's internal dynamics of thrust and counterthrust. In some works, it marks the intersection of opposing movements. Figures become part of a linear web stretched across the surfaces of the painting (figs. 6, 8). Black lines describe mostly dynamic forms (figs. 11–13). And, their description of forms, people, landscape, objects, with their angularity and implied movement, is reminiscent of African sculpture.

At the same time, color is equally important. Vacillating between transparency and opaqueness, it effectively connects the structural diagrams of swifty applied black ink or watercolor (plates I, II). In an essay for the exhibition "New Paintings by Bearden" (1947), Barrie Stavis, a playwright and scholar, noted among other things, Bearden's use of color. The "disharmony of yellows, violets, light green, and the use of gray as a counter-balance and neutral spatial area between the contrasting hues, help the eye to move from area of color to area of color, slipping flexibly across the canvas."

In all of his paintings, Bearden experimented with color and how it affects the perception of space. He was interested in how the placement of one color next to another affected value and tonality. He also played with the "non-colors" white and gray, often using them to restrain spatial recession or centrifugal movement (plate II, figs. 9, 10 & 11).

A quote by Galileo, underlined in one of Bearden's notebooks, is key to understanding the philosophical basis of Bearden's works.

> The Universe is the grand book of philosophy. The book lies continually open to man's gaze, yet none can hope to comprehend it who has not yet just mastered the language and the characters in which it has been written. This language is mathematics; these characters are triangles, circles and other geometrical figures.[13]

Bearden grappled with understanding and using this language, undoubtedly because of his love of mathematics. Sketches in this and other "notebooks" and in letters to his friends show that Bearden constantly investigated the use of mathematical principles in the organization of form and space in a painting. He analyzed the paintings of other artists and reduced them to rectangles containing geometric linear designs. His analytical approach is evident in his classical method of learning, which today would seem anachronistic. Bearden read widely on art, including the letters of Camille Pissarro, Vincent Van Gogh, and Jean Auguste Ingres; the *Journal* of Eugene Delacroix; and the writings of Albrecht Dürer, Piet Mondrian, Henri Matisse, Wang Wei, and Katsushika Hokusai.[14]

He also copied masterpieces of Western art, enlarging photographs of works by Giotto, Duccio, Veronese, Grünewald, Rembrandt, De Hooch, Manet, and Matisse. As he explained:

> I made reasonably free copies of each work, substituting my own choice of colors for those of these artists, except for those of Manet and Matisse when I was guided by color reproductions. The Rembrandt I chose, 'Pilate Washing His Hands' gave me the most difficulty. While studying this masterpiece, I found so many subtle rhythms and carefully planned relationships that I finally surrendered the work, having learned that there are hidden, mysterious relationships which defy analysis.[15]

Bearden's intense, methodical study of masterpieces and critical examination of his own works ironically occurred when his commercial success

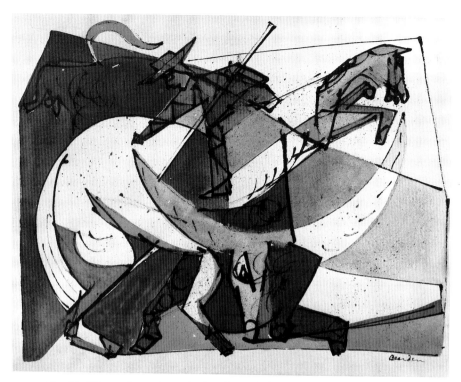

Fig. 11. *What a Great Torero in the Ring.* 1946. (Private Collection, New York. *Photo: Dawoud Bey.*)

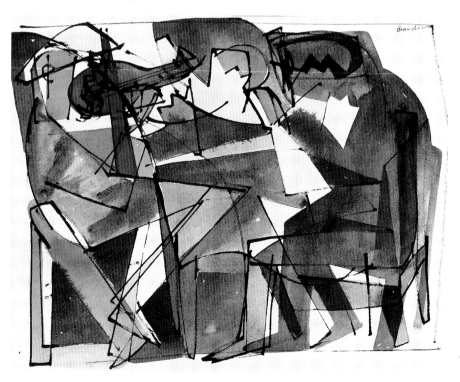

Fig. 12. *The Blues Has Got Me.* ca. 1946. (Collection Dr. Walter O. Evans, Detroit, Michigan.)

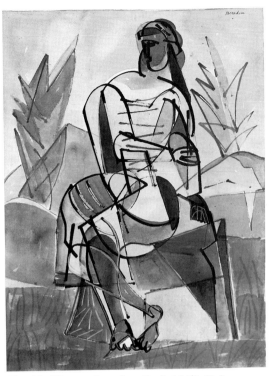

Fig. 13. *Woman Seated on Rock.* 1947. (Private collection, New York. *Photo: Dawoud Bey.*)

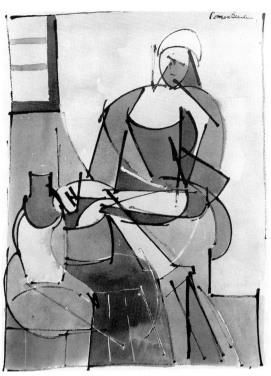

Fig. 14. *Seated Female.* ca. 1947. (Collection Morgan and Marvin Smith, New York. *Photo: Dawoud Bey.*)

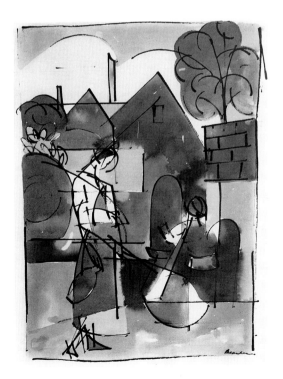

Fig. 15. *Two Women in a Courtyard.* 1948. (Collection June Kelly, New York. *Photo: Dawoud Bey.*)

in the mainstream art scene declined. The accolades from the art press subsided. In 1948, Kootz closed his gallery. When he reopened in 1949, modernism was passé. The figurative artists, Bearden, Browne, and Holty, were no longer part of the Kootz stable.

1955–1962

In 1950, encouraged by Claude McKay and Barry Stavis, Bearden traveled to Paris to study philosophy part-time at the Sorbonne on the G.I. Bill. With letters of introduction from Samuel Kootz, Bearden met Constantin Brancusi and Georges Braque. On his own, he met other writers and artists, among them Fernand Léger, Jean Hélion, Wifredo Lam, and Hans Reichel. He visited museums, galleries, and studios, and met old friends from Harlem—jazz musicians Sidney Bechet and Roy Eldridge, and singer Minata Cato; poets Sam Menashe and Samuel Allen, and writers Richard Wright and Richard Long. He also made new friends—poet Myron O'Higgins; artists Herbert Gentry, Paul Keene, William Rivers, Beauford Delaney, and Howard Swanson; and writers James Baldwin and Albert Murray, whose strong love of jazz destined them to become close friends and artistic collaborators.

Bearden did not paint while in Paris. Yet when he left, eighteen months after his arrival, Albert Murray recalls: "Romie spent the whole day buying paper, all kinds of drawing paper—rice papers, special sizes and surfaces, different colors. His eyes got more and more moist the later it got, 'This goddam Paris,' he kept saying."[16] Bearden's study of masterpieces and encounters with master artists, as well as his contemporaries, reinforced for him the importance of art history and increased his awareness of current trends. Bearden later said that "an artist should be informed about what is valid not only historically, but also in the present," and, quoting André Malraux, "art is made from art."

On his return to New York, in his new studio over the Apollo Theater at 243 West 125th Street, he faced a major creative dilemma and abandoned painting altogether. For about two years, as Bearden put it, "I just turned away from painting." In lieu of it, he composed songs. (One, "Sea Breeze," recorded by Billy Eckstein, Oscar Pettiford, and Dizzy Gillespie, became a hit.) On the advice of his friends the philosophers Heinrich Bleucher and Hannah Arendt (Bleucher's wife), and with the moral support of Nanette Rohan, whom he married in 1954, Bearden decided to paint again, concentrating on oils and acrylics. Yet, no longer interested in the modernist style of the 1940s, he was still at a creative impasse. As before, he kept pace with what was current, and, in the middle to late 1950s, the dominant style in New York was Abstract Expressionism.

Just before his brief immersion in Abstract Expressionism, Bearden completed a painting that marks a transitional period between his linear figurative style of the 1940s and his color abstraction of the late 1950s. Appearing like one of the goddesses from the Parthenon frieze, *Blue Lady* (1955, plate IV), an isolated seated, monumental figure, delineated by lines of color, is virtually obliterated by the many layers of thick paint

pulled across the canvas.[17] Artist Merton Simpson recalls that Bearden would use anywhere from two to ten layers of paint.

A *New York Times* art critic praised the color and "new freedom" in Bearden's "space-filling figure paintings," observing that linear organization had given way to a "looser, more all-over color statement."

The impastoed, granular surface seen in the *Blue Lady* is much like that of *Mountains of the Moon* (1956), suggesting the influence of Abstract Expressionism. The rectangles of blue color in varying tonality recall the "push-pull" aesthetic theory of Hans Hofmann, who dominated color abstraction in New York at the beginning of the 1950s. Assuredly, Bearden's close friend Carl Holty, who in 1926 studied at the Hofmann School in Munich, was the source of this influence. Letters from Holty to Bearden show that they shared many of the ideas which appear in Bearden's writings.[18] Their oneness of spirit is evidenced in the book they wrote together, *The Painter's Mind, A Study of the Relations of Structure and Space in Painting* (1969).

For about five years, between the late fifties and early sixties, Bearden experimented with Abstract Expressionist techniques—splashed or dripped paint, variations of the same color, and various approaches to oils, acrylics, and paper. Several were faintly reminiscent of Frankenthaler, Motherwell, or Tàpies. Bearden's canvases (usually unprimed linen) of this period, are saturated with oil or acrylic paint. Working in the classic action-painting mode, he increased the size of his paintings to approximately 60 by 56 inches. He painted the unstretched canvas on the floor, sometimes lifting it so that the paint could move freely. Color is harmonious. Layers of color that are similar in tonality suggest something ephemeral, as in *The Mirror* (ca. 1959) or *Winds of Spring* (ca. 1960). Pigments, diluted, flow across the surface, or, thickened, accumulate in encrusted areas. The effect is like a weathered frescoe or a glazed ceramic surface. The writer Harry Henderson, a friend of Bearden's, describes this period in Bearden's life as a time of experimentation, when he put aside his study of masterpieces of Western art.

As his friends and art historian Lowery Sims have noted, Bearden took an individual approach to Abstract Expressionism. Like Pollock, de Kooning, Kline, Gorky, and Rothko, Bearden, too, rejected the modernist tradition. His paintings were similar, in that they are nonrepresentational and emphasize the primacy of the two-dimensional picture plane and color. However, Bearden was not interested in the existentialism represented by contemporary American painting or in its aggressive, gestural style.

Bearden's philosophical base was Zen. Achieving in several large-scale paintings what Henderson terms "a mystical elegance," Bearden produced poetic, serene abstract art. In accordance with Zen principles, his approach to painting was intuitive. Rather than the explosive, fragmented shapes of Abstract Expressionism, his works appear to capture organic forms and energies merging and coalescing. Amorphous shapes emerge within an asymmetrical composition, as in *Blue Is the Smoke of War*,

White the Bones of Men (ca. 1960, plate VI) and *Snow Morning* (ca. 1959).

Bearden's interest in Zen was preceded by his own informal study of Chinese painting. During the 1950s, he met a Mr. Wu, who was a calligrapher and scholar of Chinese painting. Under Wu's guidance, Bearden focused on Chinese landscape painting of the Classical Periods, the seventh to mid-seventeenth centuries. Imitating them, he sought to express universal truths not bound by a specific place or time.

Critics and scholars have noted the affinity of Bearden's paintings such as *Golden Dawn* and *Old Poem* (1960, plate V) with Chinese landscape painting. In a later essay, Bearden described the change in his technique:

> I began to paint more thinly, often on natural linen where I left sections of the canvas unpainted, so that the tan linen had the function of a color. Areas of the canvas were left unfinished to allow the viewer's eye to enter the painting to complete unfinished areas with one's imagination.[19]

Critics responded positively to Bearden's works exhibited at the Michael Warren Gallery in January 1960 and the Cordier & Warren Gallery in April 1961, noting their "thinned, cool-colored paint," and "splotched and blotted" style.

At the same time, Bearden introduced another technique atypical of Abstract Expressionism, *déchirage* ("tearing away"). As Bearden later wrote in 1969:

> Then in a transition toward what turned out to be my present style, I painted broad areas of color on various thicknesses or rice paper and glued these papers on canvas, usually in several layers. I tore sections of the paper away, always attempting to tear upward and across on the picture plane until some motif engaged me. When this happened, I added more papers and painted additional movements to complete the painting.[20]

The influence of Chinese painting is apparent in the asymmetrical composition, emphasis on the essential form, and the use of a diagonally placed shape or line to lead the viewer's eye into the pictorial space found in works such as *Untitled No. 9* (1961), *River Mist* (1962) and *Blue Is the Smoke of War* (plate VI).

In a summary of his stylistic development, Bearden described this intense period from 1958 to 1961:

> I began experimenting in a radically different way. I started to play with pigments, as such, in marks and patches, distorting natural colors and representational objects. I spent several years doing this, until I gradually realized the tracks of color tended to fragment my compositions. That was when I went back to the Dutch masters, to Vermeer and De Hooch, in particular, and it was then I came to some understanding of the way these painters controlled their big shapes, even when elements of different size and scale were included within those large shapes. I was also studying, at the same time, the techniques which enable Chinese classical painters to organize their large areas, for example: the device of the open corner to allow the observer a starting point in encompassing the entire painting; the subtle ways of shifting

balance and emphasis; and the use of voids, or negative areas, as sections of pacivity [sic] and as a means of projecting the big shapes.[21]

Bearden's brief foray into Abstract Expressionism gave him valuable experience in understanding color relationships, the nature of oils and acrylics (his earlier oil paintings had imitated the effect of watercolors) and the two-dimensional canvas. But he never abandoned themes or literary sources. Unlike the Abstract Expressionists' works, his paintings also had titles (composed by his wife, Nanette). He continued to bring his knowledge of art history—in this instance, classical Chinese painting—to bear in making a work, as he created his abstract, expressionistic paintings.

1964–1965

The 1960s was an important decade for the nation, for African Americans and for Romare Bearden. The Civil Rights Movement brought together in 1963 a group of African-American artists, composers, and writers who searched for a way they could contribute to the movement. Out of that meeting, which took place in Bearden's studio on Canal Street, "Spiral" was formed. Former Spiral member Richard Mayhew recalls ongoing discussions with Bearden, Hale Woodruff, and others about their roles and worth in the mainstream American art community and of the question what is black art. These discussions obviously caused Bearden to reassess his style of painting and artistic responsibilities. "I remember Romy saying he was not being honest in what he was doing," recalls Mayhew.[22]

At the suggestion and assistance of one of the Spiral members, Reginald Gammon, Bearden enlarged his photomontages photographically. Not particularly satisfied with the results, he stored the works in a corner of his studio, where Arne Ekstrom, a New York art dealer, happened to notice them. He was unenthusiastic about Bearden's new abstract canvases but on seeing the rolled photostats declared, "That's your next show!"

The exhibition's title, "Projections" (Cordier & Ekstrom Inc., October 1964) was appropriate. It denoted both the photostat process used to make the large panels and the scale relationship between the smaller, original photomontages and the larger prints (edition of six) dry-mounted on masonite board. The smaller originals were displayed with the enlargements. The title also suggested the strong documentary nature and visual presence of the approximately twenty-seven exhibited works. The following year, Bearden had his second "Projections" exhibit at the Corcoran Gallery in Washington, D.C., his first solo exhibition in a museum (figs. 16–18, 20–23, plates VII, VIII).

The "Projections" are tableaux about Bearden's life in Charlotte, Pittsburgh, and Harlem, in which he effectively captures the sentiment and nature of contemporary Black life. There are seasonal rituals, such as planting and sowing, picking cotton, and baptisms in the river; and night ceremonies, when everyone dresses in their Saturday night best to listen to "down-home" blues or swing music at the Savoy or the Grand Terrace,

as in *Watching the Good Trains Go By* (plate VII) *Cotton* (fig. 17), *Jazz (Chicago) Grand Terrace Ballroom* (fig. 21), *Prevalence of Ritual: Baptism* (fig. 22). There are scenes of the habitual meeting and talking on Lenox Avenue, eating a meal in Charlotte, or gathering for a funeral farewell, such as *Evening 9:10, 417 Lenox Avenue* (plate VIII) and *The Dove* (fig. 16).

The mid-1960s marked Bearden's return to figurative painting. He recalled, "people started coming into my work, like opening a door." The people in his work now were mostly from his own life memories, but filtered through the history of art. The "Projections," he stated, were "not from a particular incident, but through art: Zurburan, African sculpture, Bosch, Jan Steen, Chinese Calligraphy and Mondrian."[23] In the *Sermons: Walls of Jericho* (1964, fig. 23), he evoked the feeling of a Grünewald painting, or, in *Prevalence of Ritual: Baptism*, a Zurburan painting (1964, fig. 22). Bearden explained that his photomontages developed

> Out of a response and need to redefine the image of man in the terms of the Negro experience, I know best. I felt that the Negro was becoming too much of an abstraction, rather than the reality that art can give a subject. What I've attempted to do is establish a world through art in which the validity of my Negro experience could live and make its own logic.[24]

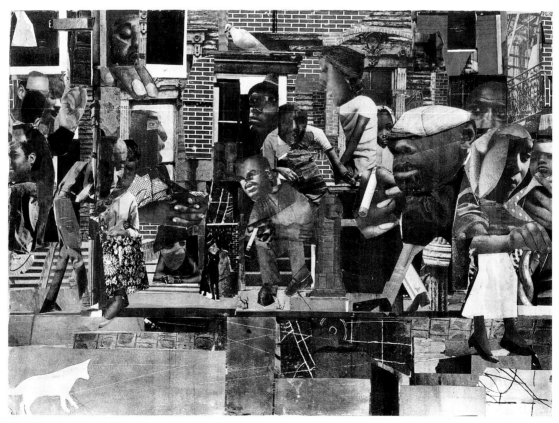

Fig. 16. *The Dove.* 1964. (The Museum of Modern Art, New York, Blanchette Rockefeller Fund.)

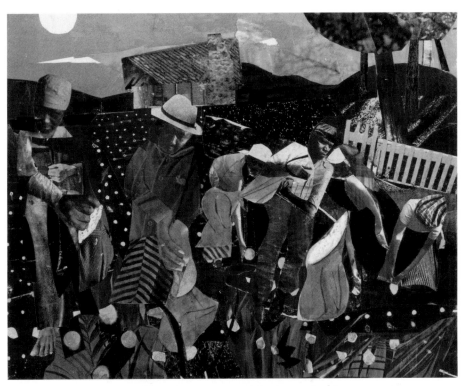

Fig. 17. *Cotton*. 1964. (Hirshhorn Museum and Sculpture Garden, Smithsonian Institution, Washington, D.C. *Photo: Lee Stalworth*.)

For Bearden, the subjects and motifs are familiar—the blues guitarists, jazz musician, mother and child, family, two women in a landscape or interior room, cat, sun, or moon; others are new—the conjure women, candles, and what Bearden called "journeying things," birds (dove and rooster), and trains. Many are scenes from urban landscapes of Harlem and Pittsburgh, often to be repeated ten years later.

Trains became a recurrent motif in Bearden's paintings (figs. 22, 25, 58, 59, 78, plates VII, XVIII). As a child, on summer evenings with his paternal grandfather, a preacher in Charlotte, Bearden "would visit the train station in the evening to watch the good trains go by." The train, which "interrupted the monotony of the hot day, and was an exciting sign of a different world," later became a cultural and historical symbol for Bearden:

> I use the train as a symbol of the other civilization—the white civilization and its encroachment upon the lives of blacks. The train was always something that could take you away and could also bring you to where you were. And in the little towns it's the black people who live near the trains.[25]

A new protagonist emerged in Bearden's collages, the conjure women, who replaced the earlier motif of the seated female, the Greco-Roman oracle. One of Bearden's more hypnotic images, the conjure woman frequently recurs in Bearden's work of the late sixties and seventies (figs.

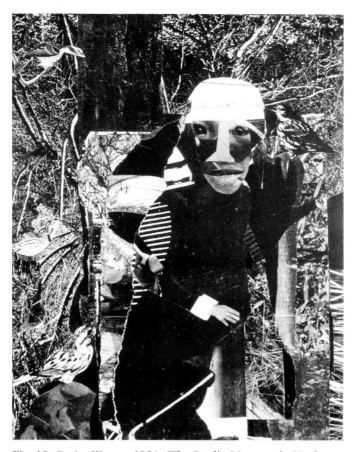

Fig. 18. *Conjur Woman.* 1964. (The Studio Museum in Harlem,
New York. *Photo: Dawoud Bey.*)

18, 19, 55). This female conjurer is a conduit for the spiritual powers and
knowledge of Africa. She represents the African diaspora. She is an
herbalist, a diviner, a priestess who manipulates unseen, unfamiliar forces
that heal or destroy. Her mysterious persona and penetrating gaze denote
her traditional stature and power in society and her significance in the
culture of African Americans. Symbolizing primal power, the conjurer is
found in the rural South and the urban North. Bearden remembered,
"Even in Pittsburgh, living in the house in back of my grandmother's,
there was an old woman much feared for her power to put spells on
people.[26]

The timing of Bearden's photomontages and photoprojections could
not have been better. The Civil Rights Movement had made people more
sensitive to social issues and more aware of the largest racial minority in
the United States. These works attracted the attention of critics, scholars,
and public. As art historian Jeanne Siegel recalls, the "Projection" paint-
ings "were radical at the time." In his artistic experimentation, and
exploration, Bearden had taken the technology of popular media repro-
duction and made it a bona fide "fine art" medium.

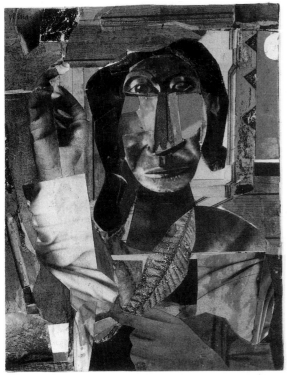

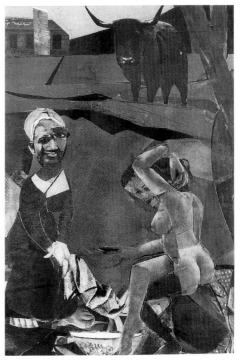

Fig. 19. *Conjur Woman.* 1964. (Collection Sheldon Ross, Huntington Woods, Michigan. *Photo: Eric Smith.*)

Fig. 20. *Prevalence of Ritual: Conjur Woman as an Angel.* 1964. (Collection Merton Simpson, New York. *Photo: Dawoud Bey.*)

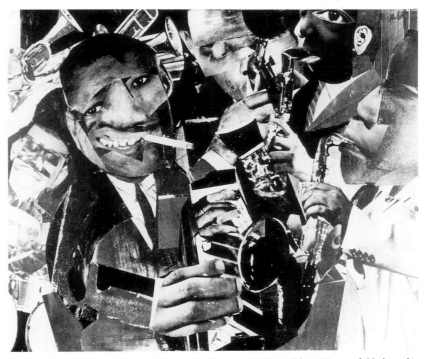

Fig. 21. *Jazz (Chicago) Grand Terrace Ballroom—1930s.* 1964. (Howard University Gallery of Art, Washington, D.C.)

Friends and colleagues were equally enthusiastic about the new work. "Romie," Crichlow remarked, "it looks like you've come home." Later Crichlow said, "It was not only an aesthetic but, an emotional breakthrough for Romie. There was something entirely fresh about them, about that vision."[27]

The political climate of the sixties was ripe for critics to emphasize the social content, the "blackness," of the "Projections." While the technique makes the images more pronounced, with greater plasticity, they appear fractured, creating an effect of discordance (figs. 16, 17, 21–23, plate VIII). The spatial disjunction and angular images recalled the "primitivism" of African sculpture, a popular motif for the expression of black pride in the 1960s—or, what mainstream art critics took to imply political protest. Critics brought their own perception of urban black America to their response to Bearden's works. Art historian Dore Ashton, for example, saw the expressions of the faces as "accusing" and "disquieting," and the urban ghetto filled with "denizens exasperated and sullen," in her catalogue essay *Projections* (1964). But she, readily acknowledged, as others did, that Bearden's photomontages transcended mere documentation. Yet Bearden did not consider himself a Social Realist or a propagan-

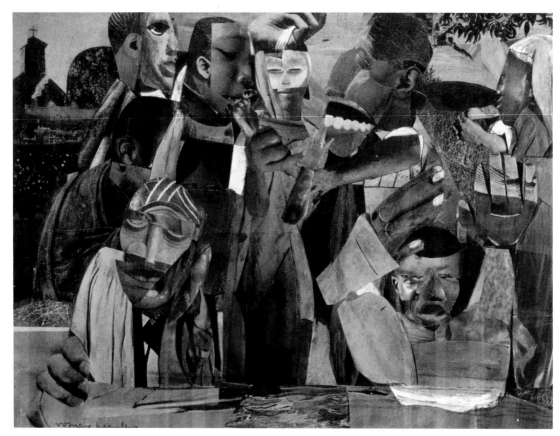

Fig. 22. *Prevalence of Ritual: Baptism.* 1964. (Hirshhorn Museum and Sculpture Garden, Smithsonian Institution, Washington, D.C. *Photo: Lee Stalworth.*)

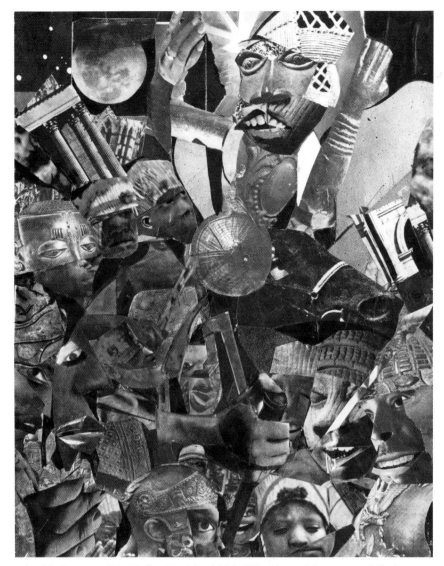

Fig. 23. *Sermons: The Walls of Jericho.* 1964. (Hirshhorn Museum and Sculpture Garden, Smithsonian Institution, Washington, D.C. *Photo: Lee Stalworth.*)

dist. Nor did he feel that his work embodied a particular political philosophy, as he revealed:

> A lot of people see pain and anguish and tragedy in my work. It's not that I want to back away from this, or to say that those things are not there. Naturally, I had strong feelings about the Civil Rights Movement, and about what was happening in the sixties. I have not created protest images. The world within the collage, if it is authentic, retains the right to speak for itself.[28]

The juxtaposition of disparate, often contrary, images created an effect that some critics felt was affected, somehow not realistic. In response to these critics, Bearden explained that through the realism of photography, he conveyed a certain humanity:

One must be very careful about the matter of racial identity and evaluating it. The difficulty is when (the artist) denies himself, or assumes other identities. As a Negro, I do not need to go looking for 'happenings,' the absurd, or the surreal, because I have seen things that neither Dali, Beckett, Ionesco, nor any of the others could have thought possible; and to see these things I did not need to do more than look out of my studio window above the Apollo theater on 125th Street. So you see this experience allows me to represent, in the means of today, another view of the world.[29]

The enthusiastic reception of the "Projections," however, virtually eclipsed Bearden's earlier works. As mentioned earlier, Bearden had used the collage technique in abstract works of the late 1950s. But these more recent ones assuredly established Bearden's future as the consummate American collagist. With the "Projections" Bearden also achieved what he never thought would be possible—he was able to earn a living as a professional artist. In 1966, Bearden left his job at the New York City Department of Social Services to become a full-time artist. During the next two decades, the collages brought him critical success and became the hallmark of Bearden's oeuvre.

Visually, these photomontages and photostats (called photoprojections) are attractive and compelling. Faces and hands are silhouettes cut from photographs of water, sheet metal, leaves. A large superimposed human eye often dominates a face. Such imagery jolts the viewer's perception. The composition is a two-dimensional design, within which are small areas of realistic space created by the photograph. Photographs of textiles, water, cloth, wood, leaves, grass, and metal are combined in sophisticated designs of shapes and patterns. All elements are placed in reference to a simple structural scheme or a vertical or horizontal line, a right angle, a curve and countercurve. The compositions are actually similar to Bearden's earlier abstract paintings, with the irregular shapes of color now photomontage, as in *Prevalence of Ritual: Baptism* (fig. 22).

The "Projections" are predominantly monochromatic. Grays predominate, and, with white, function as a visual respite and counterpoint, allowing the viewer's eye to rest amid the intense visual activity created by photographic fragments.

In a letter to a critic, Michael Gibson, of the *International Herald Tribune*, who had written an exhibition review of Bearden's photomontages exhibited at Galerie Albert Loebe (Paris, 1975), Bearden described the collage process:

> My reason for writing you is not to take issue with your opinions of my work. I do however, wish to acquaint you with a few painting techniques of mine, especially in view of your statement: 'his collages are peopled by black faces cut out of magazines.'
>
> Actually, my method is much more complex than this. In most instances in creating a picture, I use many disparate elements to form either a figure, or part of a background. I build my faces, for example, from parts of African masks, animal eyes, marbles, mossy vegetation, etc. I then have my small original works enlarged so the mosaic-like joinings will not be so apparent,

after which I finish the larger painting. I have found when some detail, such as a hand or an eye, is taken out of its original context and is fractured and integrated into a different space and form configuration, it acquires a plastic quality it did not have in the photograph.

So, many persons have asked me: 'My you must have a large collection of magazines and photographs.' Really I don't. Any reproduction will suit my purpose, because, like the acient [sic] makers of mosaics, I'm really drawing and painting with these snippets of grayed papers. In this, I've attempted to incorporate techniques of the camera eye and the documentary film to, in some measure, personally involve the onlooker. Without going too far beyond selected aspects of reality, I try to transform them, as they are often seen conventionally, into an intense aesthetic statement. I feel the method is rather unique.[30]

Looking at the paintings in retrospect, one sees, in the interplay of various values of gray, a cleansing of the palette, and a honing of technique in preparation for the next flurry of activity, another artistic peak from 1967 to 1969.

In this transitional period, Bearden was experimenting with collage styles. Two are discernible, beginning around 1965. The *Woman* (1965, fig. 24) and *Farmhouse Interior* (1965, fig. 26) exemplify them. One uses minimal color and line; the other, abundant color and design. In the first group of collages, color is abraded from the paper surface, and line is either drawn or formed by the accumulation of pigment at the edges of cut paper (figs. 24, 42, 44, 52, 61, plate XV). Capturing the essentials of form, expression and movement, line continued to be an important element in Bearden's art. The style of the latter group of collages, however, is most typical of Bearden's work beginning around 1967.

Affirmation: Paintings from 1967 to 1988

From 1967 to 1969, Bearden produced some of his most innovative, expressionistic, and robust, often monumental, work. It is inimitably Bearden, with each montage painting incorporating characteristic visual elements and technique accumulated over forty years of artistic endeavor.

Bearden painted his largest figurative collages during this time. Life-size schematic figures, usually two, stand frontally or in profile. Their iconic poses and gestures; their placement in the foreground and body position are highly suggestive of ancient Egyptian or archaic Greek friezes, and equally reminiscent of the Mexican muralist tradition and fourteenth-century Italian panel paintings or frescoes. Because of their scale, the figures conjure a sense of myth, their mundanity disappearing in the magnificence of Bearden's style.

Memories of Mecklenburg County, North Carolina, rebound in these works after the predominantly urban images of three years before. The rituals of African America confirm Bearden's emotional bond with the rural South; see, for example, *Melon Season* (1967, fig. 28) *The Family* (1967, fig. 32), *Rites of Spring* (1967, fig. 29), *Guitar Executive* (1967, fig.

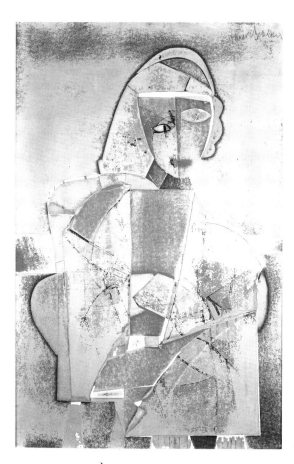

Fig. 24. *Woman*. 1965. (*Photo courtesy Sid Deutsch Gallery, New York.*)

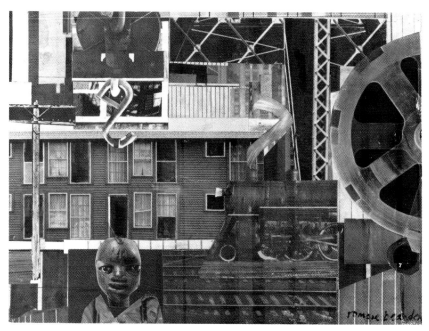

Fig. 25. *Pittsburgh*. 1965. (Collection Beatrice and Harry Henderson, Croton-on-Hudson, New York.)

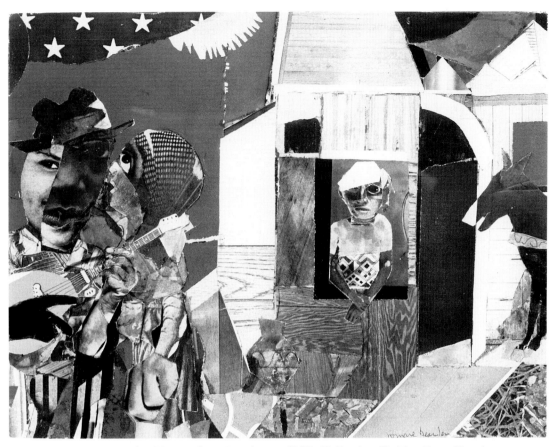

Fig. 26. *Farmhouse Interior*. ca. 1965. (Collection Sheldon Ross, Huntington Woods, Michigan. *Photo: Eric Smith.*)

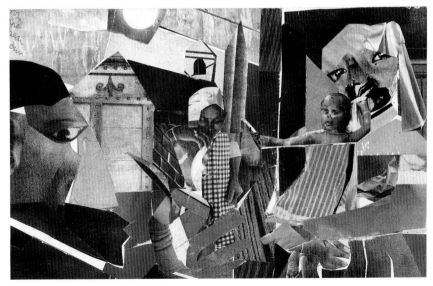

Fig. 27. *La Primavera*. 1967. (Private collection, Michigan, courtesy Sheldon Ross Gallery, Birmingham, Michigan. *Photo: Eric Smith.*)

30), *The Three Folk Musicians* (1967, plate X), *La Primavera* (1967, plate XI), *Two Women* (1968, fig. 35), *Serenade* (1968, plate XII), *Return of the Prodigal Son* (1967, fig. 31) and *Eastern Barn* (1968, fig. 33).

In a few of the paintings collage elements are mounted on canvas instead of the usual masonite or paper board. Six such works are included in this exhibition (figs. 28, 29, 31, 32, 35, plate X). Also, the paintings combine collage with more mixed media, such as acrylics, drawing, and oils. Some of the paintings (usually rectangles of color) are acrylic with added collage elements. Others were made with an initial layer of collage, and the paint was added afterwards. The paintings are visually rhythmic. Sections of photographs and paper and cloth translate as tone, hue, texture, line. There are photographed textures: various materials, elements of nature, and people. There are mosaics of real textures: heavy, brightly colored paper, or brown (kraft) paper, oil or acrylic paints, slick surfaces of photocopies (xerox), or black and white photographs. Each collage element retains its integrity as a medium, yet is harmonious to the whole.

The key to understanding Bearden's adoption of the collage technique is that Bearden considered the technique to be painting as his letter to the critic Gibson attests. In another instance, Bearden said: "I paint on collage. I consider them paintings, *not* collage. I use collage, pieces of paper that I've painted on myself.[31]

Bearden incorporated elements of previous works, reconfiguring them into his new art form (plate XII, figs. 30–32). Brown kraft paper (used as early as the 1940s) streaked with brilliant color recalls experiments in the fifties with, as he described it, "tracks of color up and down and across the canvas." There are also segments of brown kraft paper with traces of graphite drawings that he did as early as the late 1930s. Some of the photographs he uses appear to be photostats or photocopies of his Abstract Expressionist paintings of the late fifties and early sixties, with their diffused, painterly surfaces. They, in turn, are inserted amid photographs of African masks and peoples' faces and hands. It is as if Bearden were documenting his own art history for posterity.

As Bearden puts it, he sought to resolve the technical problem in the interplay between a photograph and an actual painting by "adjusting color to the grays of the black and white photograph." Key to Bearden's understanding of color theory were the ancient frescoes at Villa of the Mysteries, Pompeii. He referred to them when he cited the centuries-old problem of how an artist can accommodate large gray areas within brilliant color (fig. 42). In these ancient frescoes, the figures and drapery were painted in tones of black, white, and gray, on a background of orange-red. By manipulating the simple palette, these ancient artists were able, as Bearden was, to make figures project spatially forward without being consumed by the intensely colored background. In many paintings, as mentioned previously, he used either a blue-gray or a green to harmonize with the gray because they are tonally related colors. As he described in his essay, "Sometimes, in order to heighten the character of a

painting, I introduce what appears to be a dissonant color where the reds, browns and yellows disrupt the placidity of the blues and greens.[32]

In *La Primavera* (1967, plate XI) and *Summer Song* (1967, plate IX), the various tones and areas of gray placed next to red alter the intensity of color and sense of space. Of *The Three Folk Musicians* (1967, plate X), Bearden noted:

> The heavy red in the ground and upper right-hand areas was called for by the brightly colored orange guitars of the musicians. The figures in this painting are, for the most part, painted in oil. The relations of the other colors and shapes to the bright orange, which is certainly the most dominant color, produced some unusual effects. The figure on the far right is quite ghost-like, probably because of the contrast with the red brick wall, and, also, because of the opposition of the more solid appearing central figure, which is both light and dark in value.[33]

During the late 1960s, Bearden also produced large- and small-scale works in which the background areas of primary color increased in proportion to the figures, as in *Courtyard Sky* (1968, fig. 36) *Continuities* (1969, fig. 37), *Black Manhattan* (1969, fig. 38) and *Patchwork Quilt* (1969, plate XIII). Also, the number of collage photographs decreased. These and similar works such as *Blue Interior, Morning* (1968) and *Blue Monday* (1969, fig. 39) are keenly reminiscent of Mondrian, the rectangular blocks of color emphasizing the paintings' flat surfaces and limiting spatial recession.

The shapes of the collage elements, background, and composite figures or objects make readily apparent the underlying compositional structure of horizontal and vertical lines. To alleviate the static, controlled, geometric design, Bearden created a rhythmic syncopation of smaller collage elements seen in the figures. His architectural environments, especially interiors, as in *Summer Song* (1967, plate IX), *Courtyard Sky* (fig. 36), *Blue Monday* (fig. 39), and *Patchwork Quilt* (plate XIII) are particularly effective, with Mondrian-like designs superimposed upon compositions inspired by the seventeenth-century Dutch genre paintings of Pieter de Hooch and Vermeer.

Both color and a rectangular grid emphasized the two-dimensional surface of the painting. At the same time, Bearden manipulated his media to create the illusion of three-dimensional space.

> I first put down several rectangles of color, some of which, as in a Rembrandt drawing, are in the same proportion as the canvas. I next might paste a photograph, perhaps of a head, in the general area where I expect a head to be. The type of photograph does not matter, as it will be greatly altered. At this stage I try only to establish the general layout of the composition. When that is accomplished, I attempt ever more definite statements, superimposing other materials over those I started with. I try to move up and across the surface in much the same manner as I had done with the torn papers, avoiding deep diagonal thrusts and the kind of arabesque shapes favored by the great baroque painters. Slanting directions I regard as tilted rectangles,

and I try to find some compensating balance for these relative to the horizontal and vertical axes of the canvas. I do not burden myself with the need for complete abstraction or absolute formal purity but I do want my language to be strict and classical. In that sense, I feel my work is in the tradition of most of all the great exponents of flat painting. I have drawn on these styles, which I feel are timeless and historically durable, to control my images in pictorial space. I have incorporated techniques of the camera and the documentary film to, in some measure, personally involve the onlooker. Without going too far beyond selected aspects of reality, I try to transform them, often as they are perceived conventionally, into an intense aesthetic statement.[34]

For the next two decades, Bearden further refined his style and continued to pursue the subject of African-American genre, ritual, and myth (figs. 41–46).

In the paintings shown at two exhibitions in the 1970s, "Romare Bearden" (paintings grouped into three series, "Prevalence of Ritual," "Martinique," and "The Rain Forest," Cordier & Ekstrom Inc., 1973) and "Romare Bearden, Odysseus" (Cordier & Ekstrom Inc., 1977), he achieved visual simplicity and epical effect. Mostly large scale work, reminiscent of the body of paintings produced around 1967 and 1968, show Bearden's continued interest in abraded color surfaces, color tones and compositional balance. With these works, he used larger and fewer collage elements, and he emphasized one dominant color, green or blue, and flat shapes of objects and people. The effect often is dramatic. Landscape and architecture function like stage props, figures appear as if in an operatic scene, seemingly less significant than their environment. Shapes (figures and objects) of different sizes are juxtaposed in the same spatial plane. Yet they do not appear to be placed illogically because of their scale relationship to the architecture and landscape, a compositional device Bearden learned from studying Dutch and Chinese painting. Like them, he reveals the essential two-dimensional nature of painting as in *Noah, Third Day* (1972, fig. 51), *Reverend John's Sermon No. 1* (1973, plate XV), *Prologue to Troy No. 2* (1972, fig. 52), *The Fall of Troy* (1974, fig. 50), *The Sea Nymph* (1977, fig. 63), and in smaller "Odysseus" watercolors (figs. 47–49).

Bearden returned to Western myths, and, sometimes by altering the details, usually by making the figures black, he made them relevant to African Americans (fig. 48). He thereby showed the universal relevance of myth as in *The Fall of Troy* (1974) and *The Sea Nymph* (figs. 50, 63); *Reverend John's Sermon No. 1* (1973, plate XVI); and *Prologue to Troy, No. 2* (1972, fig. 52). In *Reverend John's Sermon No. 1*, an episode from the Old Testament (Joshua) symbolizes the sermons called "The Sun Do Move" by the southern Baptist preacher John Jasper. (The Old Testament sermon was also the basis for James Weldon Johnson's *God's Trombones*.) Referring to Lucas Cranach the Elder's *Judgment of Paris* (1530), the model for *Prologue to Troy, No. 2*, Bearden explained:

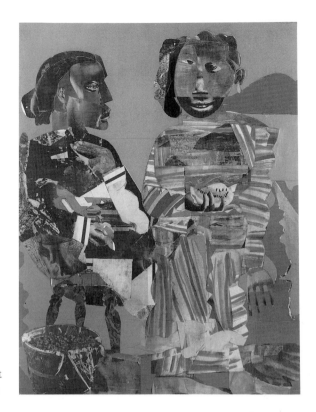

Fig. 28. *Melon Season.* 1967. (Neuberger Museum, State University of New York at Purchase, New York. *Photo: Earl Ripling.*)

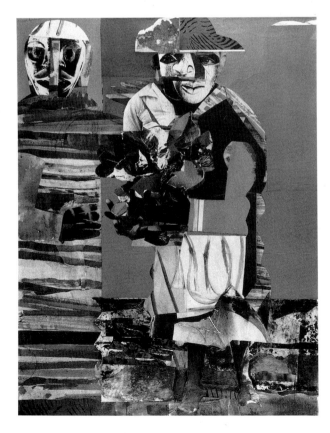

Fig. 29. *Rites of Spring.* 1967. (Collection R. L. Lewis, New York).

51

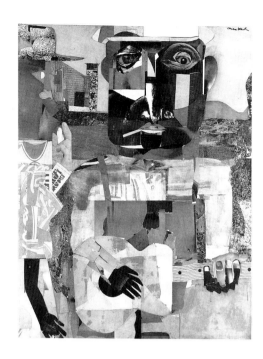

Fig. 30. *Guitar Executive*. 1967. (Spelman College, Atlanta, Georgia. *Photo: Michael McKelvey*.)

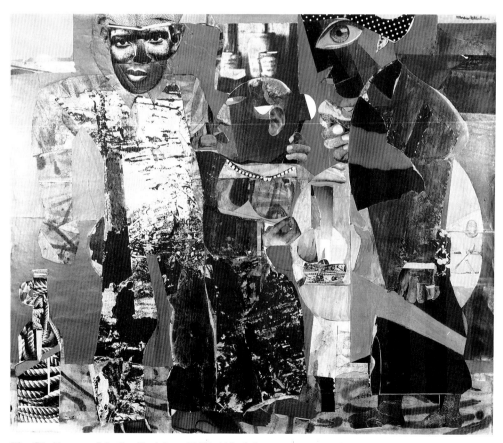

Fig. 31. *Return of the Prodigal Son*. 1967. (Albright-Knox Art Gallery, Buffalo, New York.)

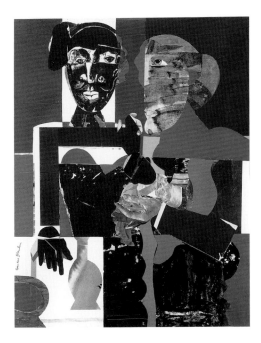

Fig. 32. *Family.* 1967/68. (The Museum of Fine Arts, Boston, Massachusetts.)

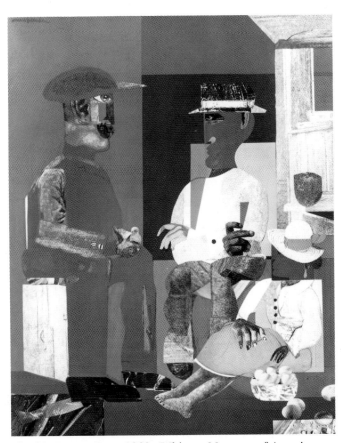

Fig. 33. *Eastern Barn.* 1968. (Whitney Museum of American Art, New York. *Photo: Geoffrey Clements.*)

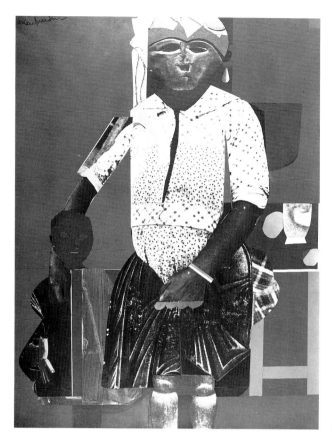

Fig. 34. *Mother and Child.* 1968. (Crocker Art Museum, Sacramento, California.)

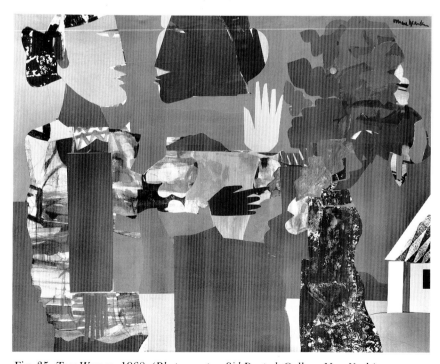

Fig. 35. *Two Women.* 1968. (*Photo courtesy Sid Deutsch Gallery, New York.*)

54

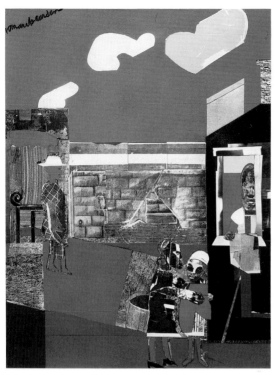

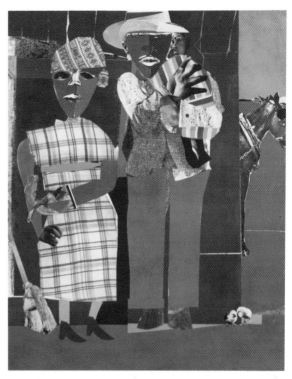

Fig. 36. *Courtyard Sky.* 1968. (Collection Jane and David Shapiro, Washington, D.C. *Photo: Alex Jamison.*)

Fig. 37. *Continuities.* 1969. (University Art Museum, Berkeley, California. *Photo: Colin McRae.*)

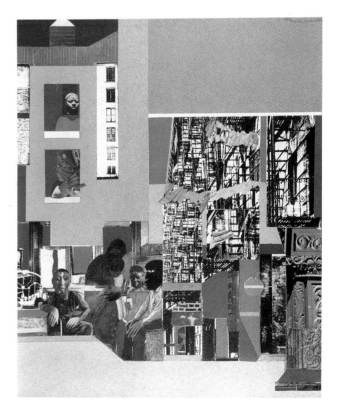

Fig. 38. *Black Manhattan.* 1969. (Schomburg Center for Research in Black Culture, The New York Public Library. *Photo: Lee White.*)

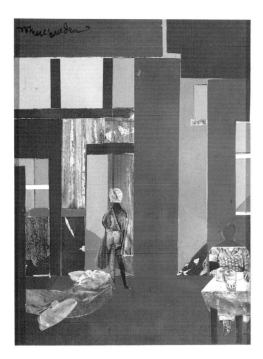

Fig. 39. *Blue Monday.* 1969. (Private Collection, Michigan, courtesy Sheldon Ross Gallery, Birmingham, Michigan. *Photo: Eric Smith.*)

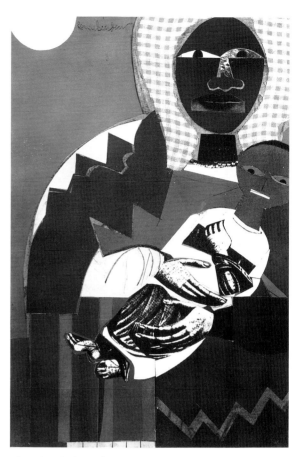

Fig. 40. *Black Madonna and Child.* 1969. (Hirshhorn Museum and Sculpture Garden, Smithson Institution, Washington, D.C.)

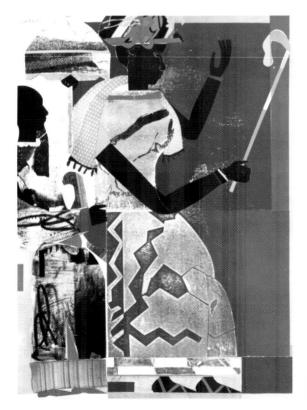

Fig. 41. *She-Ba.* 1970. (Wadsworth Atheneum, Hartford, Connecticut.)

56

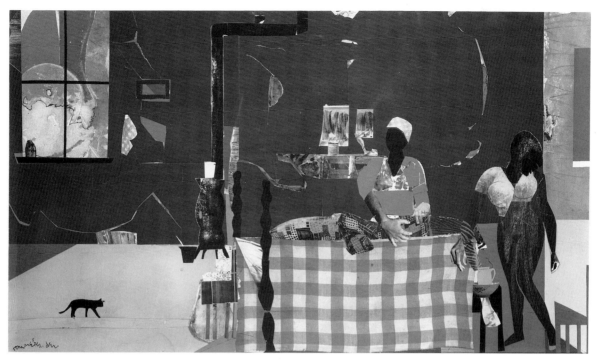

Fig. 42. *Hometime*. 1970. (Butler Institute of American Art, Youngstown, Ohio. *Photo courtesy Sid Deutsch Gallery, New York*.)

Fig. 43. *Carolina Interior*. 1970. (Private collection, Michigan.)

Fig. 44. *The Witnesses.* 1970. (CIBA-GEIGY Corporation, Ardsley, New York.)

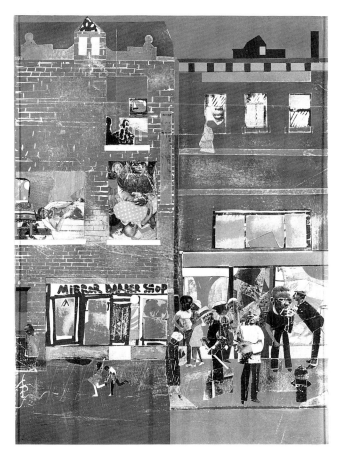

Fig. 45. *The Block.* 1971. (Detail, panel 6.)
(Collection The Metropolitan Museum
of Art, New York.)

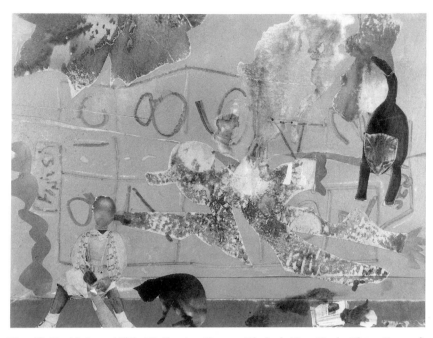

Fig. 46. *Untitled.* ca. 1971. (Collection Rowan Khaleel, New York. *Photo: Dawoud Bey.*)

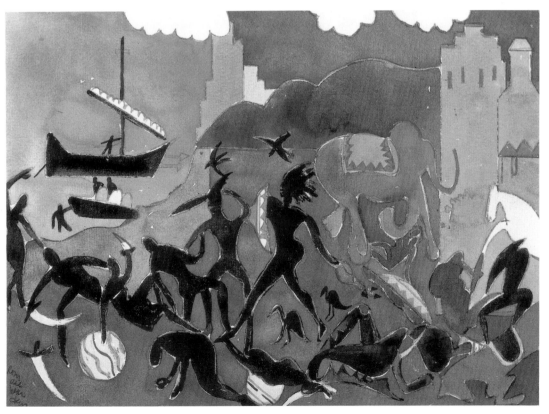

Fig. 47. *Battle with the Cicones.* ca. 1972. (Private collection, New York. *Photo: Dawoud Bey.*)

59

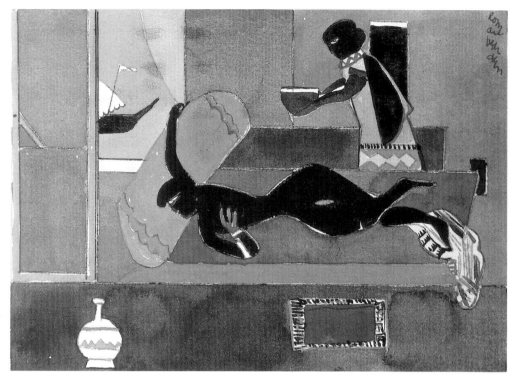

Fig. 48. *Odysseus Leaves Circe*. ca. 1972. (Private collection, New York. *Photo: Dawoud Bey.*)

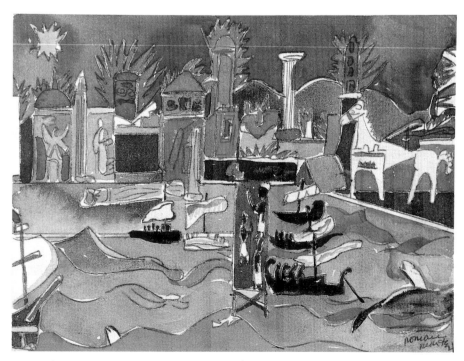

Fig. 49. *The Departure from Troy*. ca. 1972. (Private collection, New York. *Photo: Dawoud Bey.*)

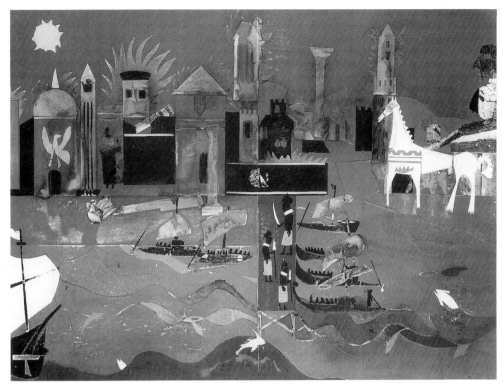

Fig. 50. *The Fall of Troy.* 1974. (Collection Dr. Florence Ladd, Massachusetts. *Photo: Eeva-inkeri.*)

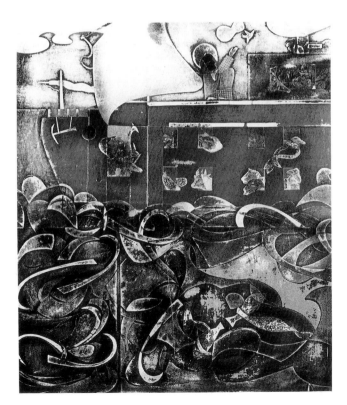

Fig. 51. *Noah, Third Day.* 1972. (The High Museum of Art, Atlanta, Georgia.)

61

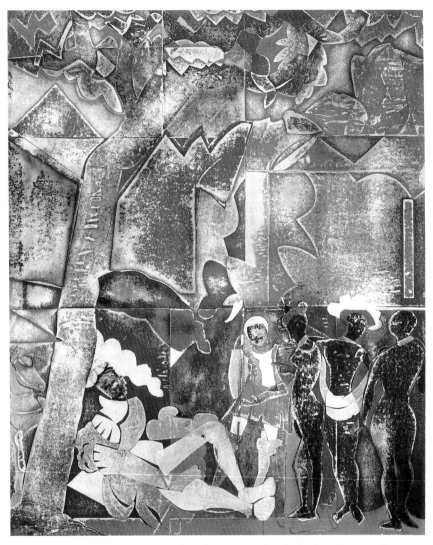

Fig. 52. *Prologue to Troy No. 2.* 1972. (Courtesy ACA Galleries, New York. *Photo: Michael Korol.*)

> I transposed Cranach to a black circumstance. The Prince—who sits in judgement [sic] is black. The Goddesses are also. All is brought to a flat plane, eliminating the depth perspective in the admittedly great work of Cranach. Paris is, indeed, not so much in judgement—as in a position of acceptance. My Paris doesn't need a stud horse in the background to point up the erotic elements. I wanted a calm, classic grandeur.[35]

In the tradition of Western art, he transformed a mundane act, a woman bathing. The setting may be the rural South or urban North, but she, bending over in or seated next to a tin tub, become the Old Testament Susannah at the Bath. The image, first painted in 1969 (in a painting titled "Susannah at the Bath") and repeated numerous times, becomes a biblical

symbol, as in *Blue Monday* (fig. 39), *Patchwork Quilt* (plate XIII), *Carolina Interior* (fig. 43), *Morning of the Red Bird* (1975, plate XVII) and *Prelude to Farewell* (1981). The bath becomes a ritual of spiritual purification and cleansing.

Two exhibitions, "Profile/Part I: The Twenties" (1978), and "Profile/Part II: The Thirties" (1981), both at Cordier & Ekstrom Inc., were important because they showed Bearden's artistic maturation and consummate skill as a collagist. Both exhibitions were a critical success. They represented a homecoming. Bearden had returned to Mecklenburg. There is Liza, Maudell Sleet, Mr. Johnson, the women in "sportin'" houses, and the families at Baptist revivals. Collaborating with author Albert Murray, who wrote the anecdotal narratives and gave titles to the paintings, Bearden painted a compendium of his life in *Farewell Eugene* (1978, plate XIX), *Sunset Limited* (1978, plate XVIII), *Miss Bertha and Mr. Seth* (1978, fig. 68), *Uptown Manhattan Skyline: Storm Approaching* (1980, fig. 74), *Maudell Sleet's Magic Garden* (1978), and *Prelude to Farewell* (1981). Some were duplicated in smaller scale as primarily watercolor on paper (figs. 64–67). Bearden's monoprint technique and increasing interest in music made for some luxuriantly rich, explosively colored paintings.

In the 1970s, music—jazz and blues—became a significant theme and motif in Bearden's works. Upon the urging of art dealer Arne Ekstrom, nineteen paintings were exhibited in a 1975 show, "Of the Blues," which confirmed Bearden as a contemporary griot, or bard, of African-American culture, especially African-American music. His knowledge and love of music helped him to develop the African-American idiom in his art. As he explained:

> Music has always been important for me the way it has been important for many blacks. Blacks have made their own sound, their own musical language like jazz. It is theirs and they identify with it. In a world of constantly changing identities, certain forms of music represent a solid identity for blacks.[36]

"Of the Blues" (fig. 53, plate XVI) and an exhibition of monoprints, "Of the Blues/Second Chorus" (1976), received critical acclaim. These and subsequent works, including those in "Romare Bearden: Jazz" (Sheldon Ross Gallery, Michigan, 1980) and "In 4/4 Time" (Cordier & Ekstrom Inc., 1981), captured the essence of music. Images are of hot ragtime or joyous funeral marches in New Orleans' French Quarter; the smokin' rhythm of Memphis, Chicago, or Kansas City jazz clubs; the gut-bucket blues of neighborhood joints; the sophisticated big-band sounds at the Savoy, Lafayette, and Connies Inn in New York (plate XVI), or the Grand Terrace Ballroom in Chicago (figs. 21, 26, 73). As early as the 1940s, with paintings such as the *Folk Musicians* (ca. 1941), and *The Blues Has Got Me* (ca. 1946, exhibited "Homage to Jazz," Kootz Gallery, 1946, fig. 12), Bearden had acknowledged the importance of blues and jazz in his life. The tradition of Junior Wells, T-Bone Pickens, Memphis Slim, Duke Ellington, Count Basie, Fats Waller, Earl Hines, Bessie Smith, Billie Holiday, Louis Armstrong, and countless others is immortalized in

Bearden's paintings such as *Guitar Executive* (1967, figs. 30, 69), *The Street* (1975, fig. 54), *Storyville* (1978, fig. 70) and *Two Jazz Musicians* (1980, fig. 73), *Untitled* (ca. 1979, fig. 71), *Lady and the Blues* (1986, fig. 81) and *Lamp at Midnight* (1987, fig. 84).

Bearden alluded to the "call and the recall" of the blues and jazz tradition in the way he would paint a theme numerous times. Each rendition is slightly different; each time the arrangement of shapes, forms, colors, and textures reinterprets the same subject. The *Conjure Woman* is an example (figs. 18, 19, 55). *Maudell Sleet* is another (fig. 67, plate XXII). Bearden recalled: "each time it's different: I mean the facial characteristics. I wouldn't recognize her as the same woman one for the others, but it's faithful to my memory."[37]

One work, *Carolina Shout* (1974, fig. 53) incorporates two types of music. In it, as Albert Murray aptly pointed out, there are two cultural meanings.[38] Sacred and profane ritual are merged into one image. Depicting the emotional high point of the spiritual joy of baptism and gospel (compare with *Prevalence of Ritual: Baptism*, fig. 22), *Carolina Shout* is also the title of a well-known Harlem stride-piano composition by James P. Johnson. Movements and gestures of spiritual revelation are not unlike those seen in the dance hall and juke joints. Sunday morning ceremonies and Saturday night formalities are cultural affirmations.

Listening to jazz helped infuse Bearden's paintings with music. In fact, he claimed that he learned a lot about painting from listening to Earl "Fatha" Hines, which he began doing with Stuart Davis (Bearden fre-

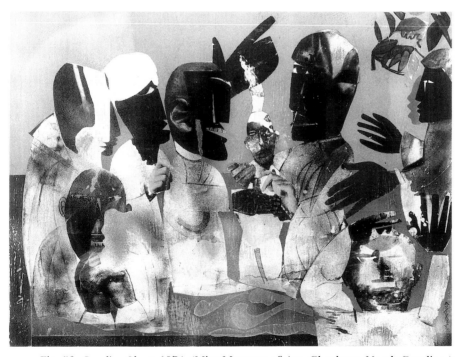

Fig. 53. *Carolina Shout*. 1974. (Mint Museum of Art, Charlotte, North Carolina.)

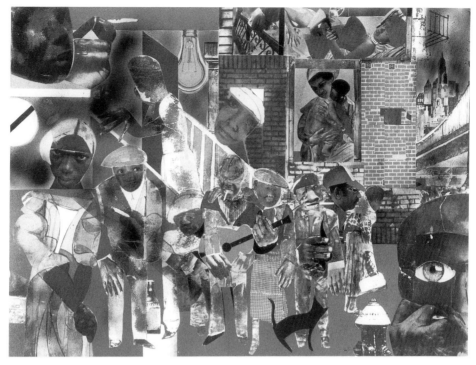

Fig. 54. *The Street*. 1975. (Private collection, Michigan, courtesy Sheldon Ross Gallery, Birmingham, Michigan. *Photo: Eric Smith.*)

quently visited his studio), who constantly played the music of Hines. As Bearden recalled:

> I listened for hours to recordings of Earl Hines at the piano. Finally, I was able to block out the melody and concentrate on the silences between the notes. I found that this was very helpful to me in the transmutation of sound into colors and in the placement of objects in my paintings and collages. Jazz has shown me the ways of achieving artistic structures that are personal to me; but it also provides me continuing finger-snapping, head-shaking enjoyment of this unique, wonderful music.[39]

Once Bearden had mastered the structural base of his paintings, his visual constant of horizontal and vertical with intervening diagonal lines, he allowed a spontaneity in the use of color and collage elements. He improvised.

These are visual intervals and pauses, or silences, the former created by the various rectangular segments within a painting (figs. 55, 62, 63). White, sometimes gray, shapes create a place for the eye to rest before engaging again in the visual syncopation of collage fragments, or the juxtapositions of different-sized figures in one spatial plane (figs. 54, 81). In Bearden's painting, gradual, three-dimensional spatial recession is absent. Instead, there are rhythmic, sometimes abrupt, spatial sequences created by real surfaces of collage, paper, photograph, or cloth (fre-

quently used in the 1970s) and photographed surfaces of objects and nature, as well as photographs of spatial distance (aerial views, close-ups). A visual rhythm is achieved not only by the use of collage segments, but by the placement of figures and objects, causing the eye to leap-frog across the picture plane and the mind to perceive movement forward and backward in space.

Around the early 1980s, pigments increasingly swell, flow uncontrollably, and seem to explode upon the surface. At times, color is flowing so profusely that the painting appears to be two: a bas-relief of collage and an expressionistic abstraction of color, as in *Cardplayers* (1982, plate XXI). Other examples of bursting color are *Rain and Sunset* and *City Lites* (fig. 76), from a series of New York cityscapes done for John Cassavetes' film "Gloria" in 1982 to be used as a backdrop for the opening film credits. Music deeply influenced Bearden's aesthetic. In his art, there is improvisation and interval, rhythm and mood. The manipulation of form, space, and color evoke musical effects, immersing us in the vividness of Bearden's imagination and recollection.

During the late 1970s and the 1980s, Bearden used more vibrant, intense, almost luminous colors, both hot and cold: pinks, oranges, acid greens, yellows, reds, purples and midnight blues.

Bearden's use of brilliant colors has been attributed to the influence of his trips to St. Martin, his wife's family home, which he took for over twenty years. After his first trip to the Caribbean island with Nanette in 1960 (and subsequent visits), many of his works acquired a tropical feeling (plates XVI, XVII, XVIII); *Indigo Snake* (1975, fig. 57), *Hidden Valley* (1976, fig. 62). Trips to St. Martin also, for the first time in many years, renewed his interest in watercolor painting, probably because of the ease of transporting them back to New York City (some were done from memory in his Long Island studio) and the limited availability of materials on the island. Also, they lend themselves to spontaneously recording images, and the range of palette could capture the mood and pulse of the island community. Bearden produced incredibly colorful and fluid landscapes, seascapes, and portraits, such as *The Lignum Vitae: Cole Bay* (1985), *Landscape* (1985, fig. 80) *Blue Lady* (1984, plate XXIV) and *Rocks on Breaking Surf* (1987, plate XXV). His fascination with ceremony and ritual was reinforced by observing actual indigenous, spiritual rites. They appear in many of these watercolors, some of which were exhibited in "Romare Bearden, Rituals of the Obeah" (1984, Cordier & Ekstrom Inc.), such as *Obeah Man with Cigar* (1984, fig. 79) and others painted later, *Death and Dancer* (ca. 1987, fig. 82) and *Carnival Dancer* (ca. 1987, fig. 83). Furthermore, Bearden revisited themes and motifs of earlier collages, displaying his draughtmanship and skill in using watercolors as in *Evening* (1975, copy of *Blue Monday*, 1967, figs. 39 & 65), *Battle with the Cicones* (ca. 1972) and *The Departure from Troy* (1972, figs. 47 & 49). Among these works, lines are fluid, minimal, yet descriptive, creating decorative patterns and curvilinear form.

Also new to his art, beginning in the 1970s, was the image of woman as

seductress. Bearden had shown woman as progenitor, queen, or spiritual healer, the conjurer (figs. 18, 19, 27, 34, 37, 40, 41, 68, 72). After a hiatus of about thirty-five years (four drawings of nudes were shown at his "306" exhibition in 1940), Bearden began depicting the female nude, but with a heightened eroticism because of the voyeuristic point of view he assumes in the paintings. For example, he presents a distant or oblique view, revealing a glimpse of a bedroom through a partially opened door. Or he presents a group of women (often from a bordello) whose uncontrived, private postures suggest they are unaware of being observed, as in *Madame's White Bird* (1975, fig. 56), *The Living Room* (1978, fig. 64), *Storyville* (1979, fig. 70), *Untitled (female nude)* (ca. 1979, plate XX), *Home-time* (1970, fig. 42), *Carolina Interior* (1970, fig. 43), and *In a Green Shade* (plate XXIII). In other works, secrecy and mystery veil faceless women (Bearden rarely depicted facial features), who walk or lie nude in tropical landscapes. They remind us of the mythological nudes of Titian, and Rubens, Delacroix or of Renoir and Manet. Still others convey sensual abandon as in *Electric Evening* (1976, fig. 60), *Dream Images,* (1976, fig. 61) and *Sunset Limited* (1978, plate XVIII).

Women are very important in Bearden's art. As art historian and Bearden scholar Mary Schmidt Campbell has noted:

> No one could doubt the reality of the women in Romare Bearden's art. Women, as he perceives them, are the heart of his community, the Black community, and his concept of women is particularly well-suited to the sensuousness of his collage technique; he has penetrated their reality and found something profound, basic.[40]

Conclusion

Romare Bearden was an extraordinary artist. He continually researched and borrowed from the art of world cultures; he experimented and explored various media and processes; he portrayed African-American genre, primarily from the South, emphasizing ritual and myth.

Bearden was a traditionalist. His methodology was academic (particularly interesting given his limited formal art training). His intellectual investigations of art ranged widely, in his search for works and writings that had a philosophical or theoretical premise. He continued his study of Western, Chinese, Japanese, and African art, which exemplified the art historical canon, until his death. But, as Bearden once wrote to a friend, the artist Walter Quirt, "Does not one of the mainsprings of the art impulse come from an artist's admiration of the works of other artists?" He used compositional devices from both Chinese and seventeenth-century Dutch painting to create the illusion of three-dimensional space and to confirm the two-dimensional nature of painting. Also, he borrowed the arrangement and placement of figures from works by Cranach the Elder, Duccio, Cezanne, de Hooch, Vermeer, Rembrandt, and Manet (figs. 14, 15, plates IX, XXI). Friends recall seeing reproductions of Vermeer and Manet in his studio; a photograph in the Smithsonian's

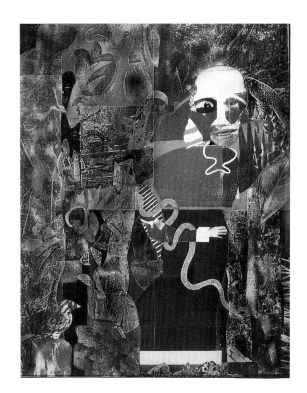

Fig. 55. *Conjur Woman*. 1975. (Private collection, Michigan, courtesy Sheldon Ross Gallery, Birmingham, Michigan. *Photo: Eric Smith.*)

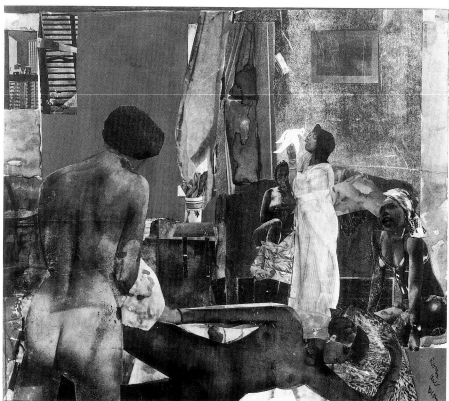

Fig. 56. *Madame's White Bird*. 1975. (Collection Jane and David Shapiro, Washington, D.C. *Photo: Alex Jamison.*)

Archives of American Art shows that he had a reproduction of Cezanne's *Cardplayers* in his studio. Several artists inspired him to experiment with imitations of their style, for example Stuart Davis, in *Midtown* (1982, fig. 77), and Henri Matisse, in *Black Madonna* (1969, fig. 40). In the early years, as Bearden searched for an idiomatic style, he imitated more closely the styles of American artists such as Charles Sheeler or Ralston Crawford (in *Anderson's Materials,* 1939, fig. 4) and European artists such as Van Gogh, Ruffino Tamayo (in *Sacrifice,* 1941), George Grosz (in *Beginning to Loom Larger and Larger on the Horizon,* 1933, fig. 1), Pierre Bonnard (in *Interior,* 1939, fig. 3), and Georges Braque (in *Lovers,* 1944). The ultimate acknowledgment of his indebtedness and a tribute to Western art history is his *Artist with Painting and Model* (1981, fig. 75).

Photographs of masks and textiles from West and Central Africa (most frequently seen in American museums and art literature) are significant images in the collages. And the sculptural configuration of angles or curves found in African art is translated into the configuration of the lines or flat shapes of the collage.

Bearden never failed to explore the inherent capabilities of a particular medium, especially paper. He used the classic collage technique, *déchirage,* tearing away paper to reveal underlying layers of paper or canvas, and the more popular collage technique of layering and overlapping different media. He would paint with acrylics, then scrub off the surface, leaving linear scratches etched into the paper and accumulations of pigments at the edges of the paper pieces (figs. 24, 43, 52, 61). He also explored the viscosity of different pigments, in watercolor, oils, acrylics, and gouache.

As a nontraditionalist, he experimented with the technique of photo reproduction, including making black-and-white photostats on canvas and duplicating monoprint originals as limited edition prints. In 1970, Bearden made collage replicas. Original collages were photographically reproduced, and the reproduction cut and reassembled according to the specifications of the original collage. A series of six of these replicas, titled *The Ritual Bayou,* were produced for Shorewood Publishers, Inc., New York. *Carolina Interior* (fig. 43) is one example of the original collage model. Bearden would also often replicate a painting image in either silkscreen or color etching prints.[41]

Also a scholar, writer, and curator, Bearden sought to redress the omission of African-American artists from the history of art. He co-authored, with Harry Henderson, a book for young readers, *Six Black Masters in American Art* (1972), and was working on another book, *A History of African-American Artists,* with Henderson (to be published post-humously). In 1966, he organized an exhibition, "Contemporary Art of the American Negro," the first such large group show in Harlem since the 1930s, which was held at Kenwood-Peter Department Store on 125th Street, New York, now the site of The Studio Museum in Harlem. In 1967, with art historian Carroll Greene, he was co-curator for the exhibition, "The Evolution of Afro-American Artists: 1800–1950," sponsored by the Harlem Cultural Council, New York Urban League, and City

College, University of New York, and held at City College's Great Hall. In 1969, he also founded, with artists Norman Lewis and Ernest Crichlow, Cinque Gallery (which still exists today), an exhibition place for younger African-American artists. In 1966, he was elected to the American Academy of Arts and Letters and the National Institute of Arts and Letters. In 1987, Bearden obtained our country's highest recognition in the arts, the President's National Medal of Arts.

As many of his friends recall, Bearden was a fantastic storyteller, whose life was full of extraordinary experiences; many of them appear in his work, a repository in which each painting represents a story, a memory, a tradition of African-American life. By the 1980s, Bearden had come full circle from the late 1930s when he first portrayed the ethos of Black people.

For him any meaningful art had to have a subject. Bearden found his subject in Black American life. Once he discovered and recognized African-American society and culture as the well-spring of his creativity, Bearden developed his own visual language. Because of it, his work eluded categorization by art historians and critics. Compared to his contemporaries, Baziotes, Davis, Gottlieb, and Motherwell, Bearden was not a mainstream artist, as evidenced by the paucity of his works in major museum collections in the United States and his conspicuous absence from the art literature. Instead, Bearden is equally or better represented in the permanent collections of universities and colleges, small and medium-sized museums throughout the country, corporations, and in numerous private collections. Although his art is essential for the history of contemporary art, his acclaim rests not in the mainstream art world, but among ordinary people, unconcerned about the avant-garde. In this regard, Bearden was successful.

Recognition by the art community did not come easily. Bearden was thirty-three when he had his first commercially and critically successful show (Kootz Gallery); forty-eight when he was rediscovered by critics as an abstract painter (Michael Warren Gallery); and fifty-three when "Projections" assured him a place in the art community and he had his first solo museum exhibition. Yet, not until fifty-nine, did he have his first museum retrospective "Romare Bearden: The Prevalence of Ritual," (The Museum of Modern Art).

Why Bearden painted what he did is best summed up by him:

> From far off some people that I have seen and remembered have come into the landscape. I let this happen. Sometimes the mind relives things very clearly for us. Often you have no choice in dealing with this kind of sensation, things are just there. Really, all sorts of people want to live and, if you let them, they will help you. There are roads out of the secret places within us along which we all must move as we go to touch others.

As he once said: "All painting is a kind of talking about life."

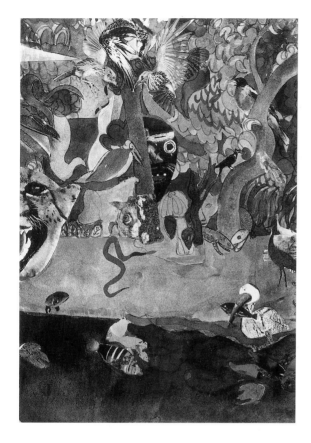

Fig. 57. *Indigo Snake.* 1975. (The Freedom Place Collection, Washington, D.C. *Photo: Alex Jamison.*)

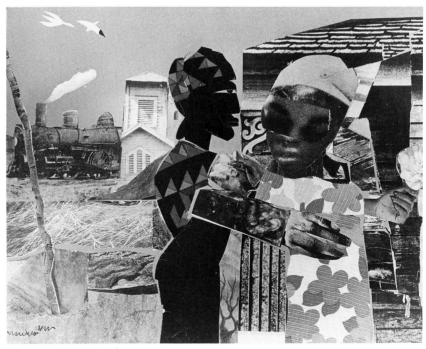

Fig. 58. *The Visitor.* 1976. (Mr. and Mrs. Richard Doerer, Grosse Pointe, Michigan. *Photo: Eric Smith.*)

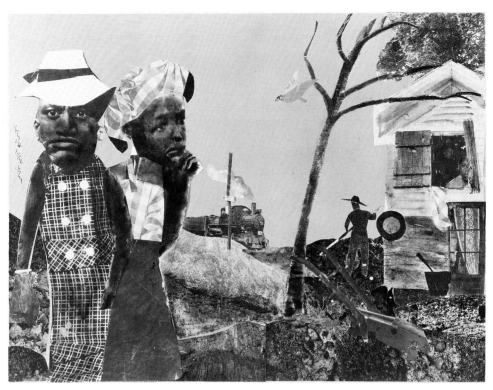

Fig. 59. *Southern Limited.* 1976. (Private collection, Michigan, courtesy Sheldon Ross Gallery, Birmingham, Michigan. *Photo: Eric Smith.*)

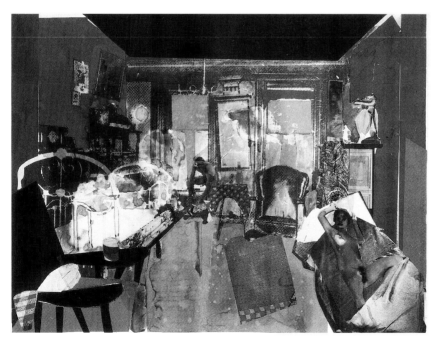

Fig. 60. *Electric Evening.* 1976. (Collection Mr. and Mrs. Sam Pearlstein, Southfield, Michigan, courtesy Sheldon Ross Gallery, Birmingham, Michigan. *Photo: Eric Smith.*)

72

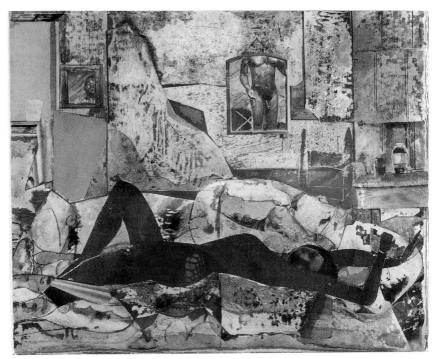

Fig. 61. *Dream Images.* 1976. (Private collection, Michigan, courtesy Sheldon Ross Gallery, Birmingham, Michigan. *Photo: Eric Smith.*)

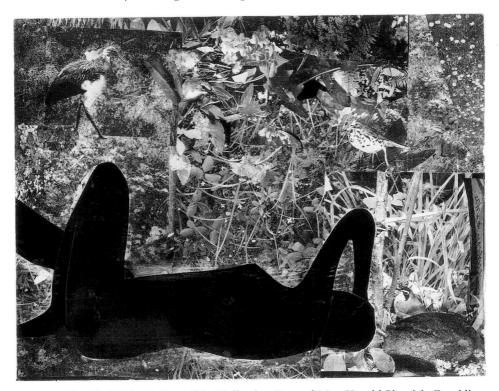

Fig. 62. *Hidden Valley.* 1976. (Collection Dr. and Mrs. Harold Plotnick, Franklin, Michigan, courtesy Sheldon Ross Gallery, Birmingham, Michigan. *Photo: Eric Smith.*)

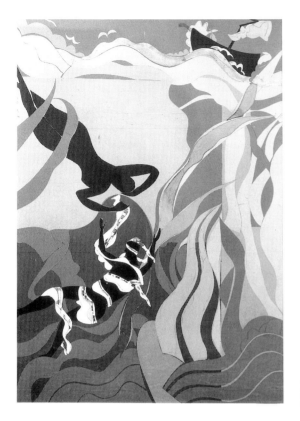

Fig. 63. *The Sea Nymph.* 1977. (Private collection, New York. *Photo: Dawoud Bey.*)

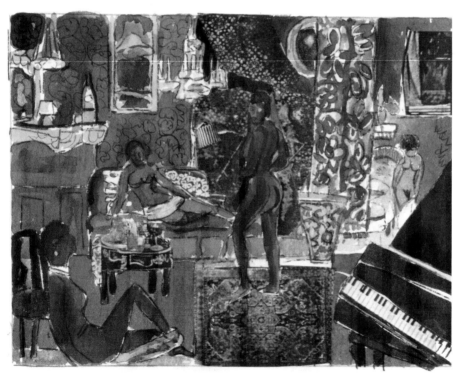

Fig. 64. *Living Room.* 1978. (Collection Sheldon Ross, Huntington Woods, Michigan. *Photo: Eric Smith.*)

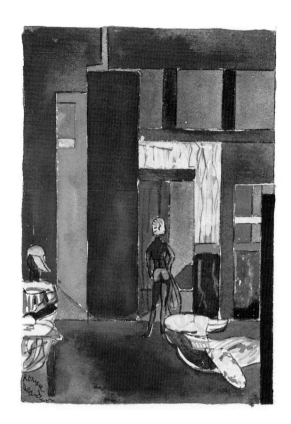

Fig. 65. *Evening*. 1978. (Private collection, Michi-
gan, courtesy Sheldon Ross Gallery,
Birmingham, Michigan. *Photo: Eric Smith.*)

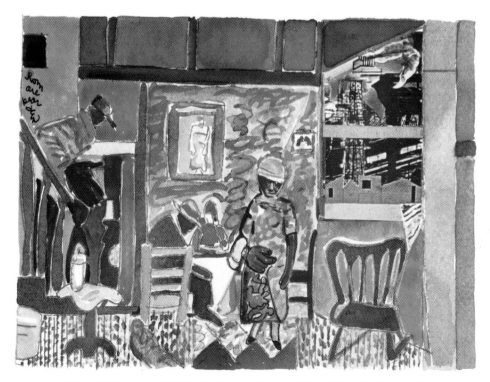

Fig. 66. *Pittsburgh.* 1978. (Collection Dr. and Mrs. S. Nagel, Southfield,
Michigan. *Photo: Eric Smith.*)

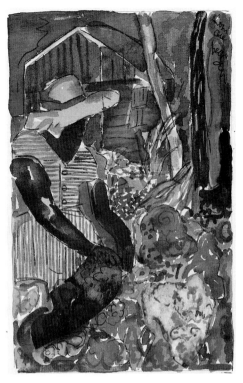

Fig. 67. *The Garden.* 1978. (Private collection, Michigan, courtesy Sheldon Ross Gallery, Birmingham, Michigan. *Photo: Eric Smith.*)

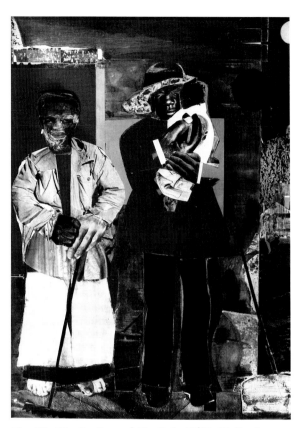

Fig. 68. *Miss Bertha and Mr. Seth.* 1978. (Collection Mr. and Mrs. Reuven Merker, Englewood Cliffs, New Jersey. *Photo: Ken Kephart.*)

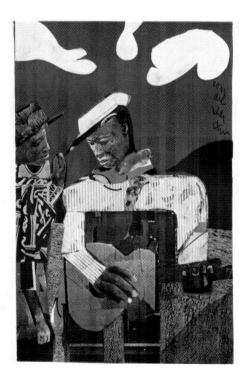

Fig. 69. *Guitar Executive.* 1979. (Collection Herman Binder, Farmington, Michigan, courtesy Sheldon Ross Gallery, Birmingham, Michigan. *Photo: Eric Smith.*)

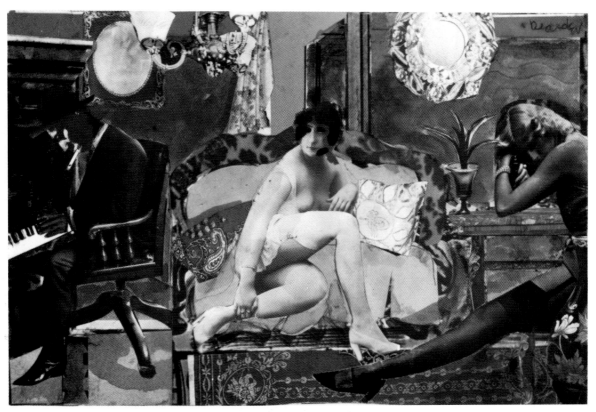

Fig. 70. *Storyville*. 1979. (Private collection, Michigan, courtesy Sheldon Ross Gallery, Birmingham, Michigan. *Photo: Eric Smith.*)

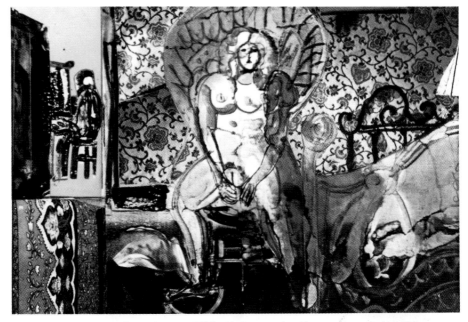

Fig. 71. *Untitled* (female nude). ca. 1979. (Arkansas Art Center Foundation, Little Rock, Arkansas. Lent by Stephens, Inc.)

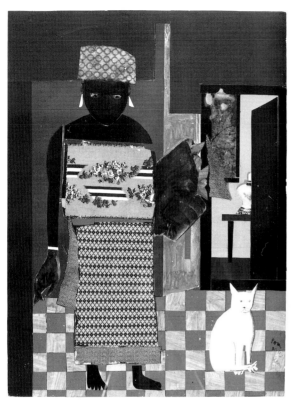

Fig. 72. *The White Cat.* 1979. (Private collection, Michigan, courtesy Sheldon Ross Gallery, Birmingham, Michigan. *Photo: Eric Smith.*)

Fig. 73. *Two Jazz Musicians.* 1980. (Private collection, Michigan, courtesy Sheldon Ross Gallery, Birmingham, Michigan. *Photo: Eric Smith.*)

Fig. 74. *Uptown Manhattan Skyline: Storm Approaching.* 1980. (Collection Mr. and Mrs. Reuven Merker, Englewood Cliffs, New Jersey. *Photo: Ken Kephart.*)

Fig. 75. *Artist with Painting and Model.* 1981. (Private collection, New York. *Photo: Dawoud Bey.*)

Fig. 76. *City Lites.* 1982. (Private collection, Michigan, courtesy Sheldon Ross Gallery, Birmingham, Michigan. *Photo: Eric Smith.*)

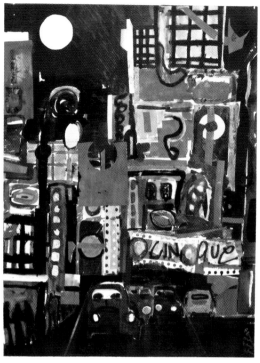

Fig. 77. *Midtown.* ca. 1982. (Private collection, Michigan, courtesy Sheldon Ross Gallery, Birmingham, Michigan. *Photo: Eric Smith.*)

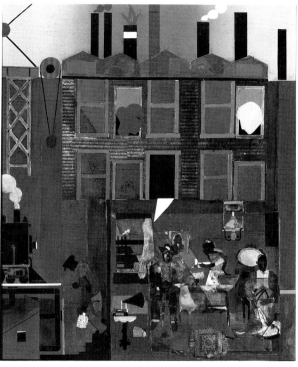

Fig. 78. *Pittsburgh Memories.* 1984. (The Carnegie Museum of Art, Pittsburgh, Pennsylvania.)

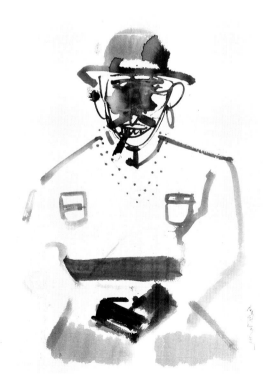

Fig. 79. *Obeah Man with Cigar.* 1984. (Private collection, Michigan, courtesy Sheldon Ross Gallery, Birmingham, Michigan. *Photo: Eric Smith.*)

80

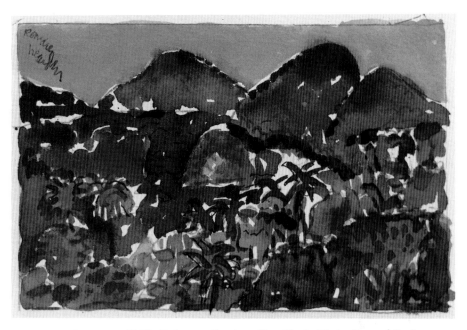

Fig. 80. *Landscape.* ca. 1985. (Private collection, New York. *Photo: Dawoud Bey.*)

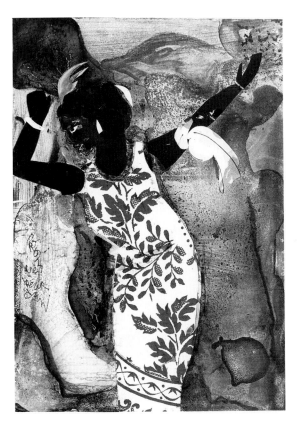

Fig. 81. *Lady and the Blues.* 1986. (Collection Lou Milano, Charlotte, North Carolina. *Photo: Bill Moretz.*)

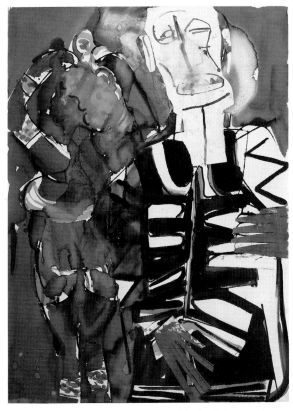

Fig. 82. *Death and the Dancer.* ca. 1987. (Private collection, New York. *Photo: Dawoud Bey.*)

81

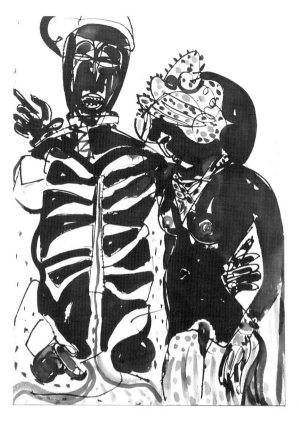

Fig. 83. *Carnival Dancer*. ca. 1987. (Private collection, New York. *Photo: Dawoud Bey.*)

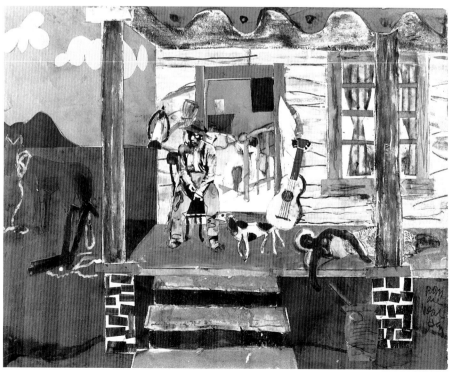

Fig. 84. *Lamp at Midnight*. 1987. (Private collection, courtesy Jerald Melberg Gallery, Charlotte, North Carolina. *Photo: Bill Moretz.*)

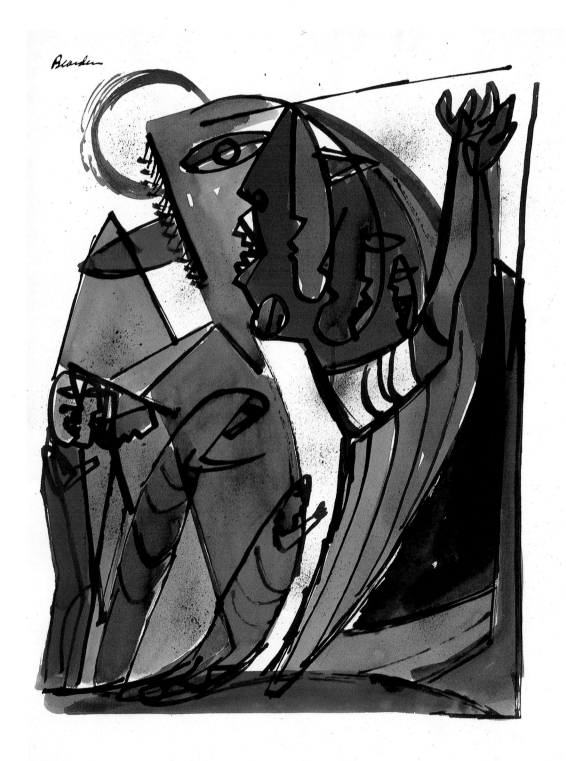

Pl. I. *He Is Arisen.* 1945. (The Museum of Modern Art, New York.)

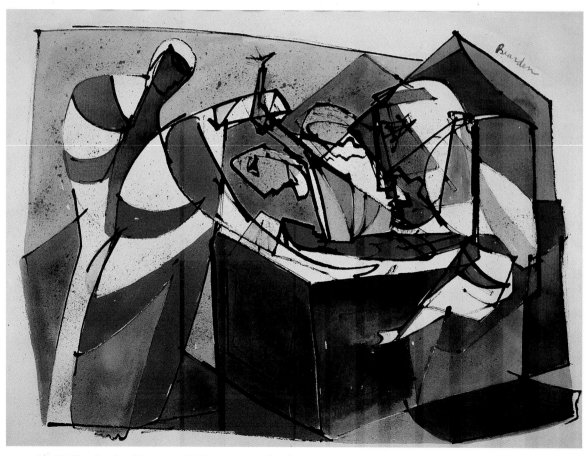

Pl. II. *You Are Dead Forever.* 1946. (Private collection, New York. *Photo: Dawoud Bey.*)

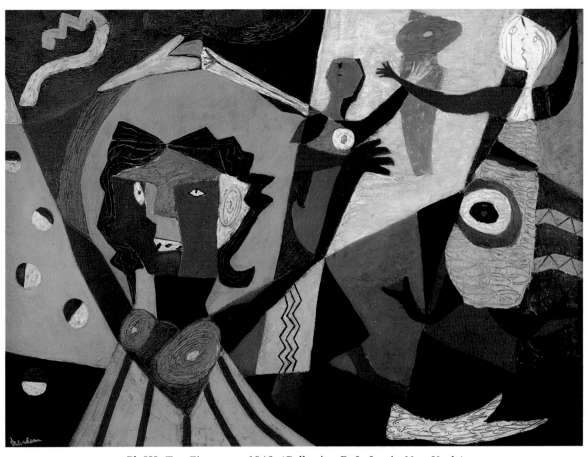

Pl. III. *Two Figures.* ca. 1946. (Collection R. L. Lewis, New York.)

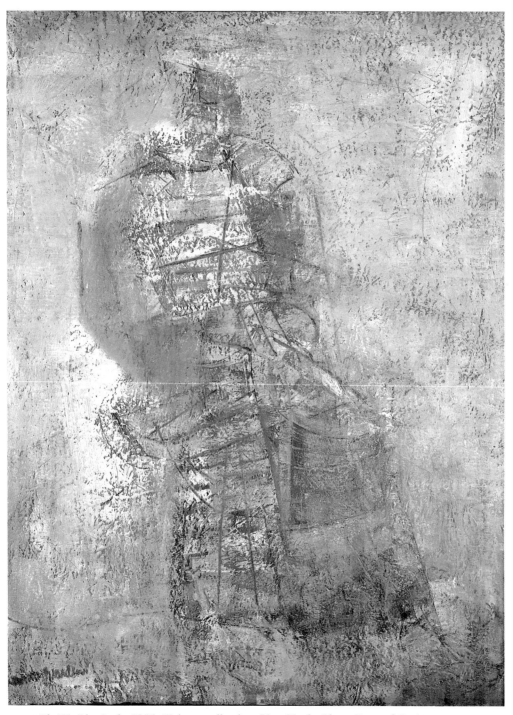

Pl. IV. *Blue Lady.* 1955. (Private collection, New York. *Photo: Dawoud Bey.*)

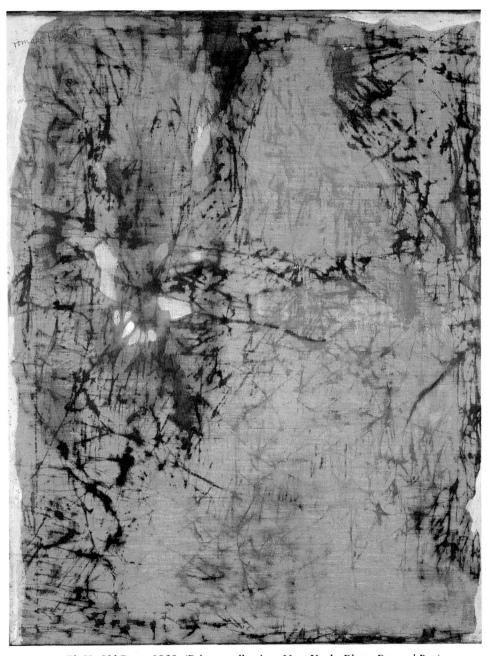

Pl. V. *Old Poem.* 1960. (Private collection, New York. *Photo: Dawoud Bey.*)

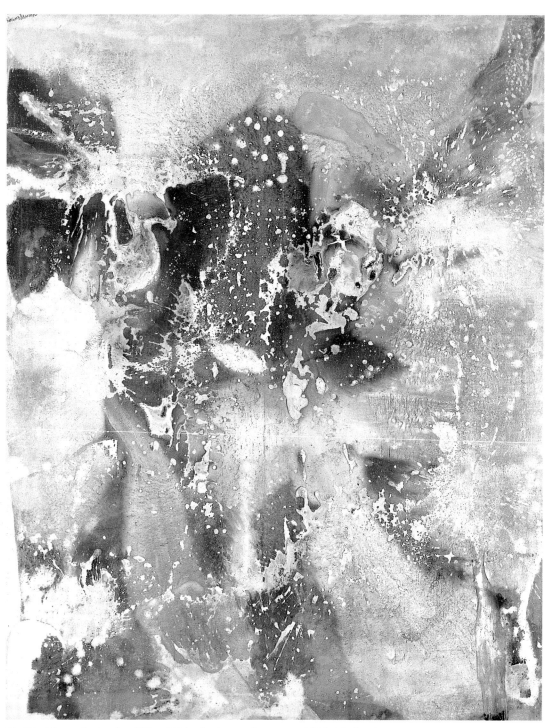

Pl. VI. *Blue Is the Smoke of War, White the Bones of Men.* ca. 1960. (Collection Beatrice and Harry Henderson, Croton-on-Hudson, New York. *Photo: Manu Sasoonian.*)

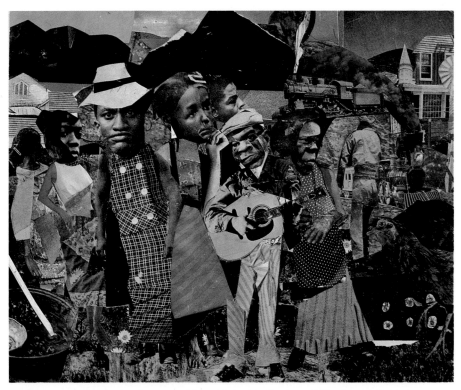

Pl. VII. *Watching the Good Trains Go By.* 1964. (Collection Philip J. and Suzanne Schiller, American Social Commentary Art 1930–1970, Highland Park, Illinois. *Photo: Sharon Goodman.*)

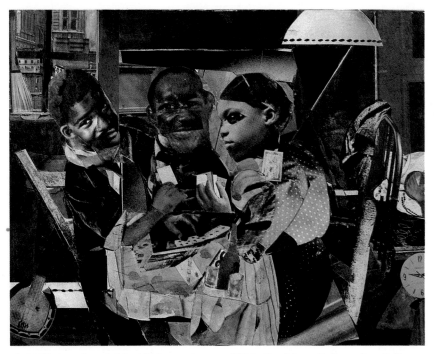

Pl. VIII. *Evening: 9:10, 417 Lenox Avenue.* 1964. (Davidson College Art Gallery, Davidson, North Carolina. *Photo: Bill Moretz.*)

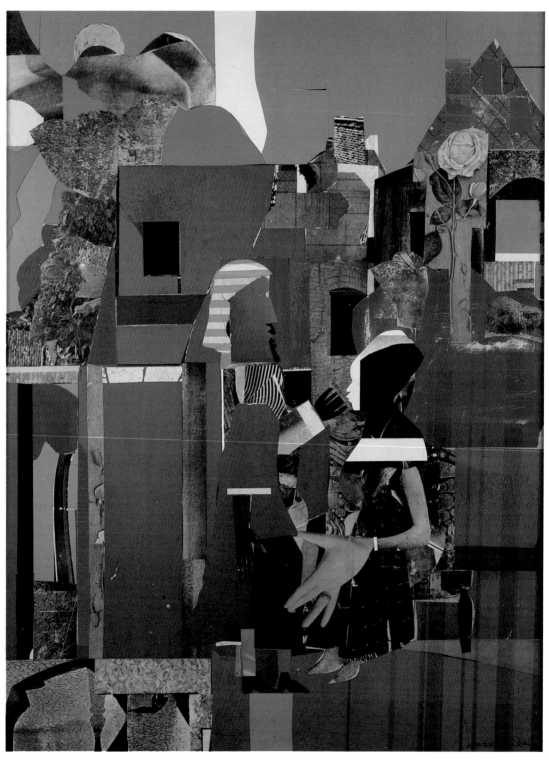

Pl. IX. *Summer Song.* 1967. (*Photo courtesy Sid Deutsch Gallery, New York.*)

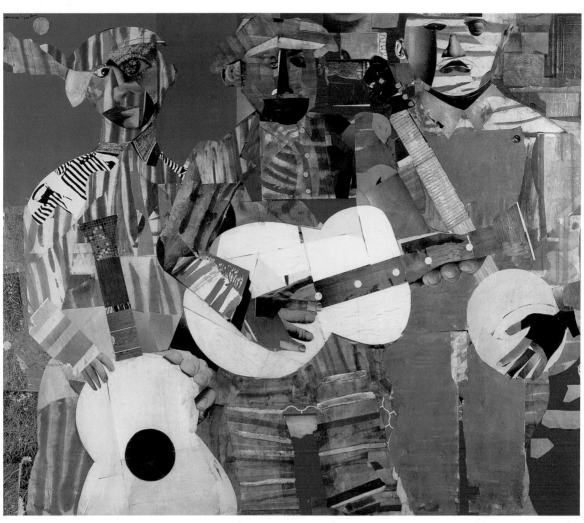

Pl. X. *Three Folk Musicians.* 1967. (Private collection, courtesy Sheldon Ross Gallery, Birmingham, Michigan. *Photo: Eric Smith.*)

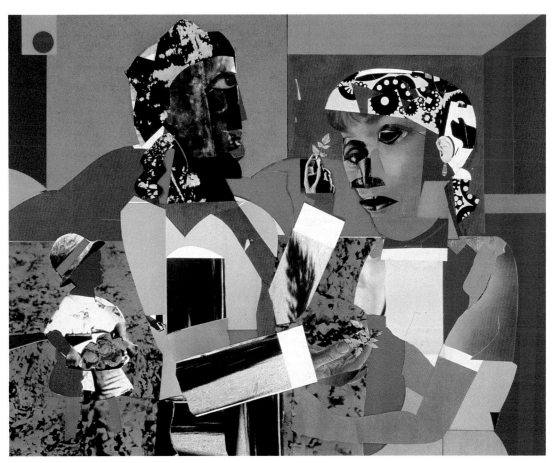

Pl. XI. *La Primavera.* 1967. (Collection Philip J. and Suzanne Schiller, American Social Commentary Art 1930–1970, Highland Park, Illinois. *Photo: Sharon Goodman.*)

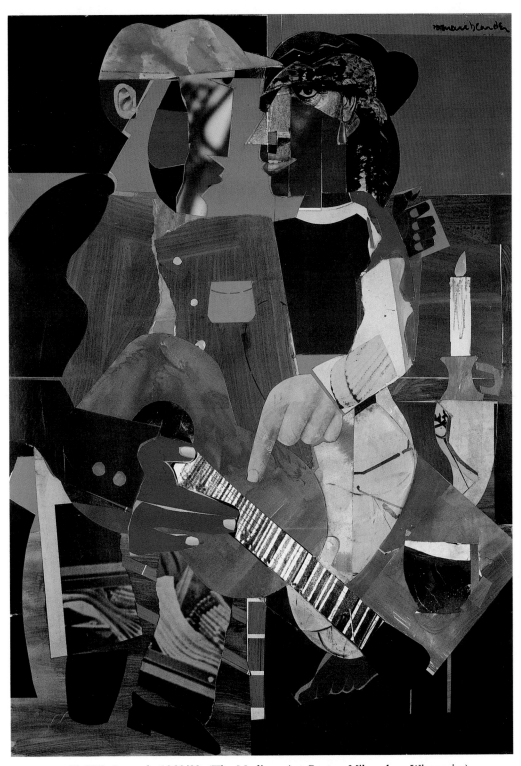

Pl. XII. *Serenade.* 1968/69. (The Madison Art Center, Milwaukee, Wisconsin.)

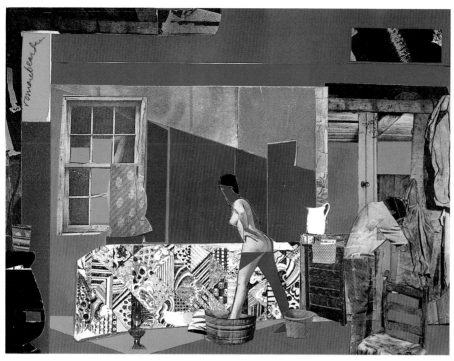

Pl. XIII. *Patchwork Quilt.* 1969. (Private collection, Michigan, courtesy Sheldon Ross Gallery, Birmingham, Michigan. *Photo: Eric Smith.*)

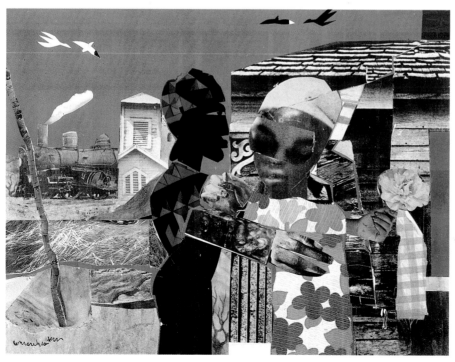

Pl. XIV. *The Visitor.* 1976. (Collection Mr. and Mrs. Richard Doerer, Grosse Pointe, Michigan. *Photo: Eric Smith.*)

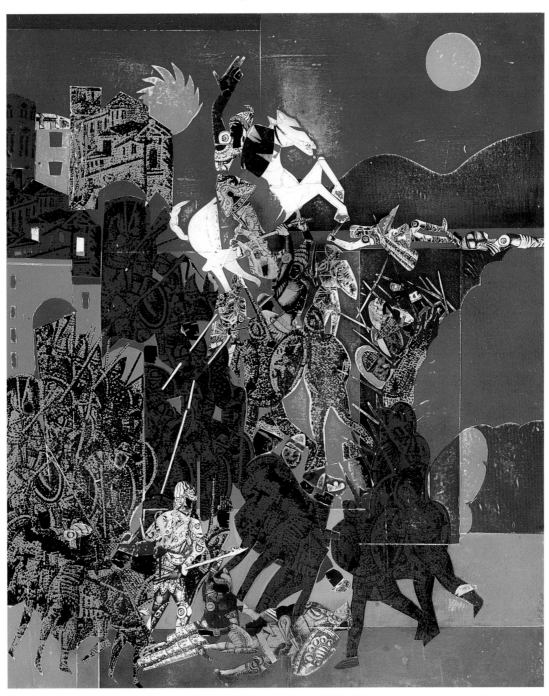

Pl. XV. *Reverend John's Sermon No. 1*. 1973. (Flint Institute of Arts, Flint, Michigan.)

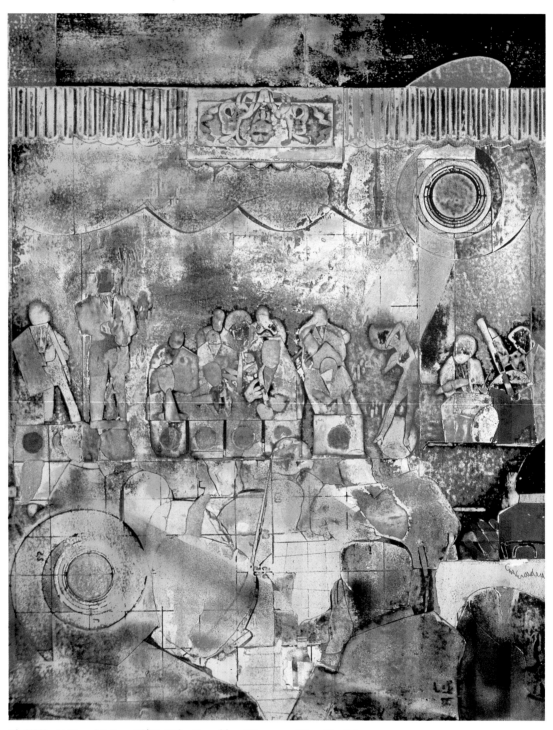

Pl. XVI. *At Connie's Inn.* 1974. (The Brooklyn Museum, New York.)

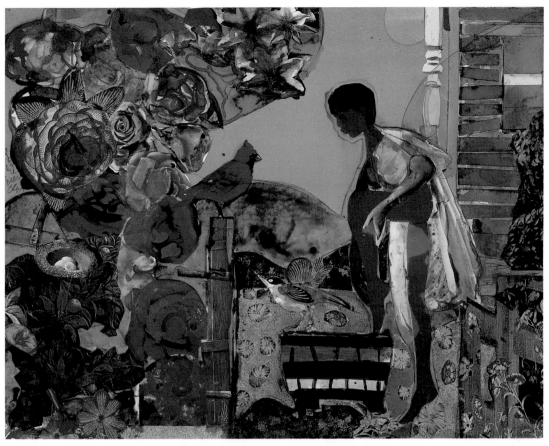

Pl. XVII. *Morning of Red Bird.* 1975. (The Freedom Place Collection, Washington, D.C. *Photo: Alex Jamison.*)

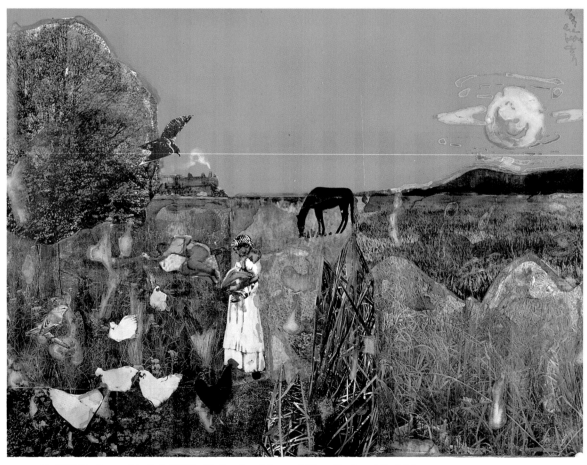

Pl. XVIII. *Sunset Limited.* 1978. (Collection Mr. and Mrs. Gerhard Stebich, Plainfield, Massachusetts.)

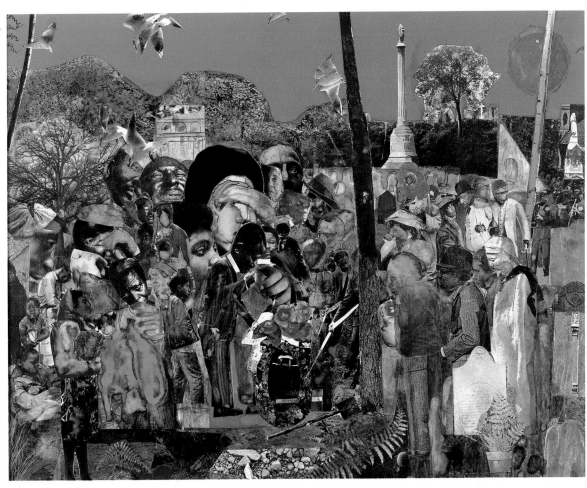

Pl. XIX. *Farewell Eugene.* 1978. (Collection Laura Grosch and Herb Jackson, Davidson, North Carolina. *Photo: Bill Moretz.*)

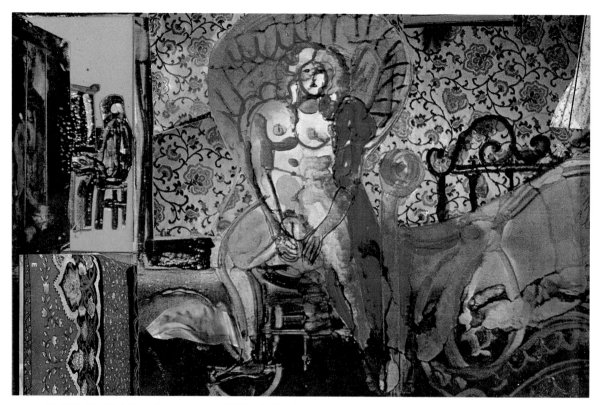

Pl. XX. *Untitled* (female nude). ca. 1979. (Collection Arkansas Art Center Foundation, Little Rock, Arkansas, lent by Stephens, Inc.)

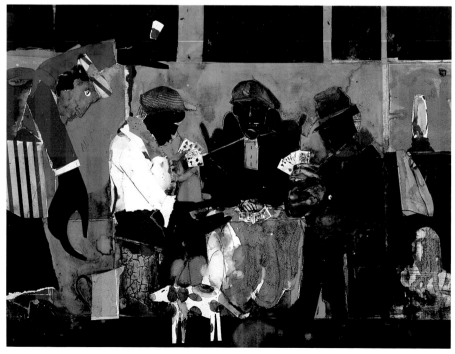

Pl. XXI. *Card Players.* 1982. (Private collection, Michigan, courtesy Sheldon Ross Gallery, Birmingham, Michigan. *Photo: Eric Smith.*).

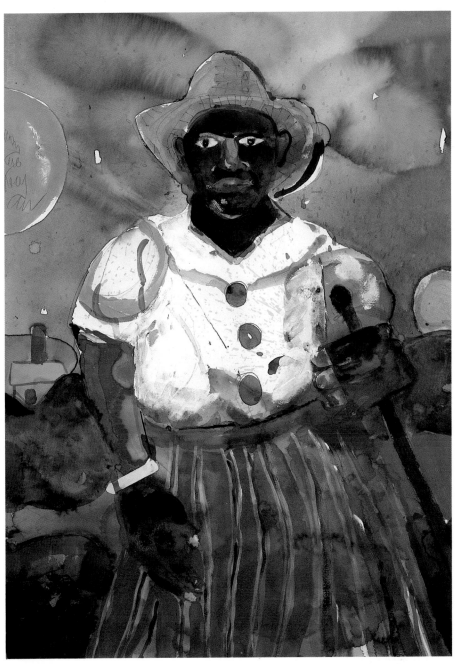

Pl. XXII. *Maudell Sleet*. ca. 1980. (Collection C. E. Boulware, New York. *Photo: Dawoud Bey*.)

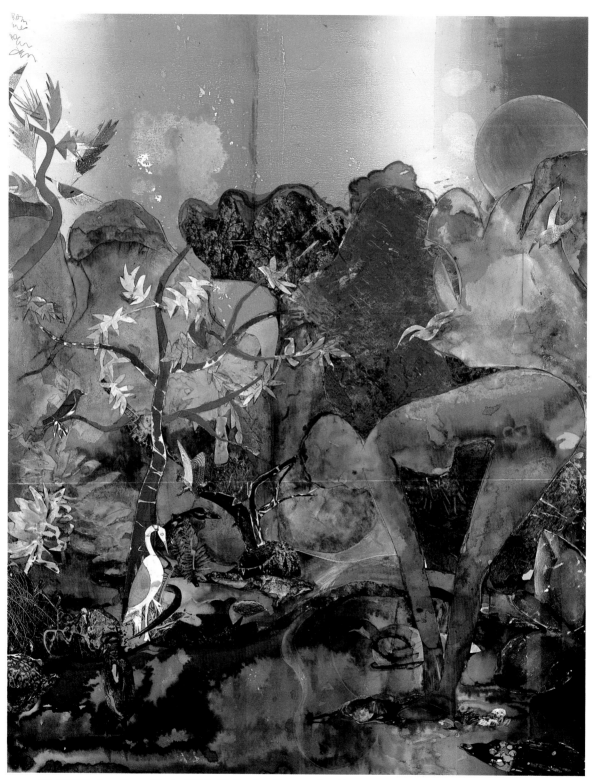

Pl. XXIII. *In a Green Shade*. 1984. (Collection Estate of William H. Van Every,
Jr., Charlotte, North Carolina, courtesy of Jerald Melberg Gallery, Charlotte,
North Carolina. *Photo: Bill Moretz.*)

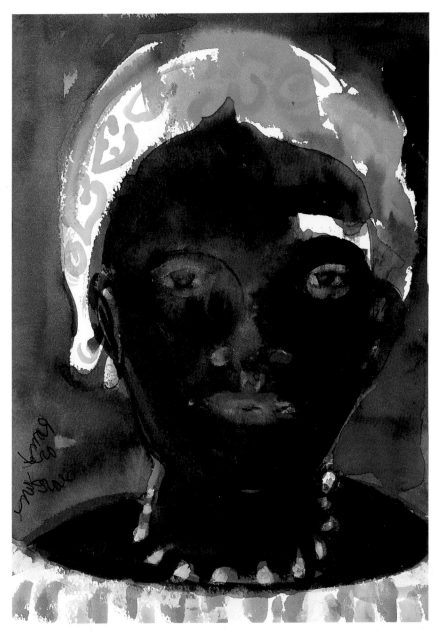

Pl. XXIV. *Blue Lady.* 1984. (Private collection, Michigan, courtesy Sheldon Ross Gallery, Birmingham, Michigan. *Photo: Eric Smith.*)

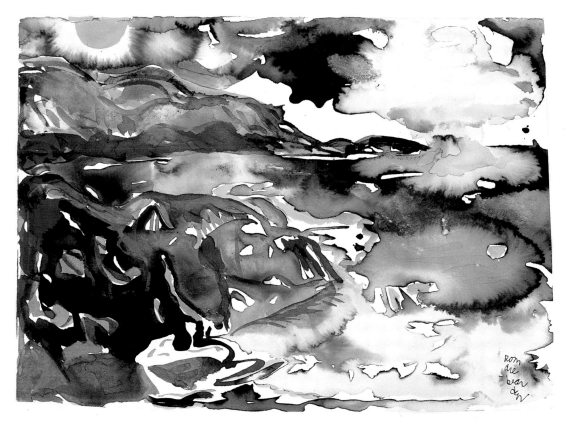

Pl. XXV. *Rocks on Breaking Surf*. 1987. (Private collection, Michigan, courtesy Sheldon Ross Gallery, Birmingham, Michigan. *Photo: Eric Smith.*)

NOTES

1. Bearden's birthdate has been given as 1911, 1912, or 1914. The Register of Deeds in Charlotte, North Carolina, his birthplace, record Bearden's date of birth as September 2, 1912.

2. Calvin Tomkins, "Putting Something Over Something Else," *The New Yorker* (December 28, 1977):55. Bailey's drawings were of the house of prostitution where he lived with his mother until Bearden's maternal grandmother "adopted" him. When Bailey died about a year later in 1925 Bearden was a pallbearer at his funeral. The subject of the bordello with its rolling piano music would appear later in Bearden's paintings.

3. Bearden continued drawing cartoons for the magazine until 1936. There are fourteen drawings of Bearden's cartoons for the *Medley* in New York University's archives. See Mary Schmidt Campbell, "Romare Bearden: A Creative Mythology," Ph.D. Dissertation (New York: Syracuse University, 1982), fn. 2, p. 39. Bearden also knew another African-American cartoonist, Oliver Harrington. One drawing for *Colliers*, "Pardon Me But Could You Direct Me to the Oceanic Dredging Co.?", is in the permanent collection of the Museum of Modern Art, New York, and dates around 1935. There are approximately eight drawings in the permanent collection of the Schomburg Center for Research in Black Culture, Art and Artifact division, New York Public Library, New York. They show Bearden's interest in social genre, and date between 1936 and 1938.

4. Romare Bearden, interview by James Hatch, December 6, 1972, tape recording, Hatch-Billops Archives, New York. As part of President Franklin D. Roosevelt's New Deal, the Federal Arts Project of the WPA employed artists, many of them as muralists. For Bearden's description of that time, see Tomkins, "Putting Something Over Something Else," p. 55. Bearden's family income disqualified him for enrollment in the WPA.

5. The Harlem Artists Guild (1935–1941) was an organization of professional artists, many of whom had started with the WPA. The Guild was formed in reaction to the WPA's practice of not appointing African Americans to the board. Its objective was to organize exhibitions and foster recognition of African-American artists. Some of the artists also established the Harlem Art Center (1937–1942) where Bearden later exhibited his works in the early 1940s. Artists Aaron Douglas and his successor Augusta Savage were directors. Evidence suggests he joined the Guild around 1941, because Lawrence recalled Bearden was not a member when he was in New York (Lawrence left New York ca 1941). Prior to that time Bearden was undoubtedly aware of guild discussions and issues through contact with his friends and his cousin, Charles Alston. (Jacob Lawrence and Ernest Crichlow, personal communication, July 1990).

For additional information about this period in Harlem, see Campbell, "Romare Bearden: A Creative Mythology," pp. 50–53; Diedre Bibby, *Augusta Savage and the Art Schools of Harlem* (New York: Schomburg Center for Research in Black Culture, 1988), and *Charles Alston: Artist and Teacher* (New York: Kenkeleba Gallery, 1990.)

6. "Professor" Siefert's home had the largest collection of history, literature, and art publications about Africa and African-Americana in Harlem and, many believed, in New York City. In 1935, Siefert took Bearden and others to the "African Negro Art" exhibition at the Museum of Modern Art. Siefert's lasting impression on Bearden is described in both Tomkins, "Putting Something Over Something Else," p. 57, and Campbell, "Romare Bearden: A Creative Mythology," p. 52. Ernest Crichlow, personal communication, July 1990.

7. Romare Bearden, "Rectangular Structure in My Montage Paintings," *Leonardo* 30 (1969):11. His eclectic studies under Grosz also included Rembrandt and Persian miniatures. His first oil painting was in the style of Daumier. See Elton Fax, *Seventeen Black Artists* (New York: Dodd, Mead & Co., 1971), pp. 135–36. Bearden had two copies of Grosz's book, *Ecco Homo* (Berlin: Malik-Verlag, 1923).

8. E. Fax, *Seventeen Black Artists*, p. 136. The exhibition included eighteen paintings depicting rural Southern and urban Northern scenes of Black life. For additional information about 306, refer to Tomkins' article, and *Charles Ashton*, pp. 20–21. The *Amsterdam News*, in the only known review of Bearden's exhibition, praised the quality and Social Realist style of Bearden's work. Some artists responded less favorably to the Black genre subject matter. In a letter to Walter Quirt, Bearden mentioned one artist (nameless) who thought he deliberately painted what "critics think a Negro should paint like." Letter, Romare Bearden to Walter Quirt, January 10, 1942 (Collection Eleanor Quirt).

9. Romare Bearden, "The Negro Artist and Modern Art," *Opportunity, Journal of Negro Life* (December 1934):371–72. Most texts on African-American art cite this essay as an example of the debate about black art within the artistic community. The issues raised in this article continue today.

The Harmon Foundation, created by William E. Harmon in the early 1920s, sponsored five art exhibitions between 1928 and 1933. The objective was to foster an African-American art devoid of any academic, Western art influence and to emphasize race consciousness in art. Some of the early exhibitions (several traveled) were lambasted by critics and artists, including Bearden, for promoting inferior work. The Harmon Foundation had a sizable permanent collection which, when the Foundation closed in the 1960s, eventually ended at the National Museum of American Art (formerly the National Gallery of Fine Art). They arranged gifts to other institutions throughout the country. Ironically, one work by Bearden was part of the Harmon Foundation Collection (fig. 3). For additional information, see Gary Reynolds and Beryl Wright, *Against All Odds, African-American Artists and the Harmon Foundation* (New Jersey: Newark Museum, 1990).

Again, in his article "The Negro Artist's Dilemma," *Critique* (November 1946):16–22, Bearden emphasized the importance of art representing current trends, and not an enforced racial aesthetic.

10. Charles Childs, "Bearden: Identification and Identity," *Art News*, 63 (October 1964):61.

11. Bearden, "Rectangular Structure in My Montage Paintings," p. 12. Bearden took his works to Joe Walchecko. At other times, he photostated reproductions of paintings by Giotto, Veronese, Rembrandt, Manet and Matisse. Bearden took big sheets of brown paper, then added shellac; using a brush he

copies the reproductions mostly in black and white. Romare Bearden, Interview by Carl Fortress, June 28, 1970, tape recording, Archives of American Art, Smithsonian Institution, Washington, D.C.; interview by James Hatch, December 6, 1972, tape recording, Hatch-Billops Archives, New York.

12. Both Matthew S. Witkovsky and Lowery Sims point out that in the late 1940s many of the Abstract Expressionists' interest in abstraction was predicated on the study of non-Western cultures and a belief in the universality of archaic myths. Witkovsky emphasizes the similarities between Bearden and artists such as Motherwell, Frankenthaler, and Baziotes. See Matthew Witkovsky, "Romare Bearden and Abstract Expressionism," *Black American Literature Forum*, 23 (Summer 1989):257–82, and Lowery S. Sims, "Romare Bearden: An Artist's Odyssey," in *Romare Bearden: Origins and Progressions* (Michigan: The Detroit Institute of Art, 1986), pp. 11–20. Also see Kellie Jones, "Abstract Expressionism: The Missing Link" (New York: Jamaica Arts Center, 1986).

13. Romare Bearden, *Notebook,* n.d. in the collection, Schomburg Center for Research in Black Culture, New York Public Library. Emulating Delacroix, whose journal he had read, Bearden decided this would be his method of learning about art. Hence, he kept notes and made sketches and compositional diagrams. Another journal dated in the forties (Bearden Estate) is reproduced in Sims, "Romare Bearden: An Artist's Odyssey."

14. Bearden was especially interested in art's relationship to science and mathematics. The following citations were selected from notes in Bearden's *Notebook* (Schomburg Center): Sir Theodore A. Cook, *The Curves of Life, being an accounts of spiral formations and their application to growth in nature, to science and to art with special reference to the manuscripts of Leonardo da Vinci* (New York: Holt & Co., 1914); Adolf Hildebrand, *The Problem of Form in Painting and Sculpture* (Strassburg: J.H.E. Heitz, 1893); Roland Rood, *Color and Light in Painting* (New York: Columbia University Press, 1941); Gino Severini, *Du Cubisme au Classicisme* (Paris: Povolozky, 1921); and J.W. Power, *Elements de la Construction Picturale* (Paris: Aux Editions Antoine Roche, 1933). Bearden also noted articles such as Jere Abbott, "The Geometry of Art of el Greco," *Art Studies*, 5 (1927):91–96. These sources may have been used in preparation for his published works with Carl Holty.

15. Bearden, "Rectangular Structure in My Montage Paintings," p. 12.

16. Tomkins, "Putting Something Over Something Else," p. 59.

17. Some friends believed Bearden reused the same canvas because he could not afford to buy new canvas. *Blue Lady* appears to be an accumulation of different "studies." The seated female figure was an image Bearden returned to often in the 1940s and 1950s. *Woman with an Oracle* (1947), reproduced in the exhibition catalogue for *Woman: A Collaboration of Artists and Writers* (New York: S.M. Kootz Editions, 1948), is very similar in style to Hans Hofmann's *Seated Woman* (1944) and Carl Holty's *Woman* (1947), both of which appeared in the same exhibition at the Kootz gallery. There is also *Oracle* (c. 1954), reproduced in *The Second Annual Fall Review of Paintings and Sculptures: 1956* (Philadelphia: The Pyramid Club, 1956). The present location of both works is unknown.

Another work that is similar in style to *Blue Lady* is Bearden's *John At Patmos* (1955, oil, present location unknown), exhibited at the 1955 Whitney Museum's Biennial. For a reproduction, see Romare Bearden Papers, Archives of American Art, Smithsonian Institution, New York.

18. In this letter to Bearden, written on October 29, 1948, Carl Holty expressed theories about composition, line, and color, which are typical of the ideas shared in their correspondence:

Things to get out of drawing are—placement of shapes, the disposition of volumes and the vertical and horizontal divisions of the space—no more. That leaves the diagonal and curvilinear elements of the drawing as an entry into painting when you start putting them into the painting department you will find that your picture begins to grow immediately and you can subdivide the large form and weld it to the area generally in an asymmetrical way.

After reading Hans Hofmann's *The Search for the Real* (1948), Holty wrote to Bearden on January 29, 1949:

The vertical and horizontal divisions of the surface then serve as intervals and as constant reminders that all this activity is taking place on a *flat* surface.

For this and other letters to Bearden, see Romare Bearden Papers, Archives of American Art, Smithsonian Institution, New York.

19. Bearden, "Rectangular Structure in My Montage Paintings," p. 12. *Golden Dawn* (1960, present location unknown) hung in the Washington office of former Secretary of State Dean Rusk in 1962.

For a discussion of modernism and Abstract Expressionism in the United States, and the role of the Kootz Gallery and art historian Harold Rosenberg, see April J. Paul, "Introduction à la Peinture Moderne Americaine: Six Young American Painters of the Samuel Kootz Gallery," *Arts Magazine*, 60 (February 1985):65–71. Paul also points out its impact on three artists in the Kootz stable—Bearden, Brown and Holty.

Recent scholarship suggests there was a political agenda behind the propagation of Abstract Expressionism as a world art form and that its authentication as avant-garde art occurred for less lofty reasons than its universality as art. For the traditional point of view, see Witkovsky, "Romare Bearden and Abstract Expressionism," pp. 257–82. He cites Bearden in this context, emphasizing the similarities between Bearden's work and the gestural abstraction of Abstract Expressionism. For a revisionist point of view, see Serge Guilbaut, *Abstract Expressionism, Freedom, and the Cold War* (Illinois: University of Chicago Press, 1983).

Upon reading Paul's article and Guilbaut's book, one can better understand Bearden not fitting into contemporary mainstream art in the early fifties because of his figurative style, and in the later fifties because of his poetic quietude and color harmonies.

20. Bearden, "Rectangular Structure in My Montage Paintings," p. 12. *Silent Valley of Sunrise* (1959, Museum of Modern Art) hung in the preinaugural suite of the Carlyle Hotel, New York, of President-elect John F. Kennedy.

21. Bearden, "Rectangular Structure in My Montage Paintings," p. 12.

22. It was the first time since the Harlem Artists Guild that African-American artists in New York came together to address their needs as professional artists. Spiral's first and only exhibition was in a rented space on Christopher Street in Greenwich Village, in May 1965. See Jeanne Siegel, "Why Spiral?" *Art News* (September 1966):48–51, passim. Richard Mayhew, personal communication, September 1990).

23. Romare Bearden, interview by James Hatch, December 6, 1972, tape recording, Hatch-Billops Archives, New York. Bearden's return to the figure in his paintings may have been spurred on by his trip to Western Europe in 1961 where he observed many of the figurative works cited in his article "Rectangular Structure in My Montage Paintings."

The quote about the artistic inspirations for the two *Projections* paintings is

from an unpublished note (typescript) in the library of The Museum of Modern Art, New York.

24. Childs, "Bearden: Identification and Identity," p. 62. Also Romare Bearden, interview by James Hatch, December 6, 1972, tape recording, Hatch-Billops Archives, New York.

25. David L. Shirey, "The Black World of Romare Bearden," p. 58. Unidentified manuscript, Romare Bearden Papers, Archives of American Art, Smithsonian Institution, Washington, D.C. Trains also connote the Underground Railroad, the escape routes to the North for African-American slaves, and the means by which, after World War I, African Americans migrated from the South to the North (the Great Migration).

26. Tomkins, "Putting Something Over Something Else," p. 61. *The Dove* also recalls Bearden's adolescence in Pittsburgh. See Paul Mocsanyi, *Contemporary Urban Vision* (New York: New School Art Center, 1966):5. The importance of Pittsburgh and other steel towns to Bearden is seen as early as the 1930s, when he wanted to document through photography and art work the Northern, industrial communities of African Americans that had developed after World War I. See Romare Bearden, "The Negro in 'Little Steel'" *Opportunity, A Journal of Negro Life* (December 1937):362–65, 380. There is a "Proposal for Project on Steel Industry," dated early 1940s, in the archives of the Schomburg Center for Research in Black Culture, New York Public Library. For the complete typed transcript of article and proposal, see Campbell, "Romare Bearden: A Creative Mythology," pp. 504–14.

27. Tomkins, "Putting Something Over Something Else," p. 61.

28. *Ibid.*, p. 62.

29. *Time* (October 23, 1964). Romare Bearden Papers, Archives of American Art, New York.

30. Letter, Romare Bearden to Michael Gibson, June 15, 1975 (photocopy), Romare Bearden Papers, Archives of American Art, Smithsonian Institution, Washington, D.C.

31. Romare Bearden, interview by Carl Fortress, June 28, 1970, tape recording, Archives of American Art, Smithsonian Institution, Washington, D.C.
 For a description of Bearden's collage technique, see George A. Magnan's interview, "Romare Bearden," *Today's Art and Graphics*, 29 (1981):5–7.

32. Bearden, "Rectangular Structure in My Montage Paintings," pp. 15–16.

33. *Ibid.*, pp. 16–17.

34. *Ibid.*, p. 14.

35. Letter, Romare Bearden to Mary Schmidt Campbell, September 22, 1973. See Campbell, "Romare Bearden: A Creative Mythology," appendix D, p. 561.

36. Shirey, "The Black World of Romare Bearden," p. 67. For other writings on the relationship between blues and jazz and Bearden's art, see the following publications: Avis Berman, "Romare Bearden: 'I Paint Out of the Tradition of the Blues'," *Art News* (December 1980):60–67; Albert Murray, "The Visual Equivalent of the Blues," in *Romare Bearden, 1970–1980* (Charlotte, N.C.: Mint Museum, 1980), pp. 17–30; Edward Weeks, "Introduction," in *Romare Bearden: Jazz* (Alabama: Birmingham Museum of Art, 1982); Mary Schmidt Campbell, "Romare Bearden: Rites and Riffs," *Art in America* (December 1981):135–42; Myron Schwartzman, "Of Mecklenburg, Memory and the Blues: Romare Bearden's Collaboration with Albert Murray," *Bulletin of Research in the Humanities*, 86 (Summer 1983):140–61; John A. Williams, "Painting in Sound," *Black American Literature Forum*, 19 (Spring 1985):11–19; Myron Schwartzman, "A Bearden-Murray Interplay One Last Time," *Callaloo No. 36* (Summer 1988):410–15; Michael Harper, "Songwriting from a

Tesserae Journal," *Callaloo No. 36*, 2 (Summer 1988):403–08; Huston Paschal, *Riffs and Takes: Music in Art of Ramare Bearden* (Raleigh, N.C.: North Carolina Museum of Art, 1988); Robert L. Douglas, "From Blues to Protest/ Assertiveness, The Art of Romare Bearden and John Coltrane," *The International Review of African American Art* (1988):28–43.

37. Quoted in Schwartzman, "Of Mecklenburg, Memory and the Blues," p. 160.

38. Murray, "The Visual Equivalent of the Blues," p. 26. As with this work, Murray often selected the titles of Bearden's paintings which are metaphorical, for example *The Dove* or *The Prevalence of Ritual* (both 1954). Some of Bearden's images parallel those described in Murray's writings on music. See Schwartzman, "Of Mecklenburg, Memory and the Blues," p. 154, and Schwartzman, "A Bearden-Murray Interplay One Last Time," pp. 410–15.

39. Romare Bearden, "Reminiscences," in Paschal, *Riffs and Takes: Music in Art of Romare Bearden.*

40. Mary Schmidt Campbell, *Mysteries: Women in the Art of Romare Bearden* (Syracuse, N.Y.: Everson Museum of Art, 1975), 1.

41. "The Ritual Bayou" are six collages: *Memories, Ritual Bayou, Reunion, Mississippi Monday, Byzantine Frieze,* and *Carolina Interior.* The same title was given to reproductions intended to be an edition of seventy-five; only about twenty-five were completed before Bearden left the project. The photographically (offset) reproduced collage was cut so that the shape and size of the photographed collage pieces closely resembled the original painting. The reproductions are slightly larger than the model. For a published account of the process, see Louis Chapin, "The Medium is the Message," *The Christian Science Monitor* (July 28, 1973). Each collage edition was done by Bearden and an assistant, and signed by Bearden. They, difficult to distinguish from the original collage, have been mistaken for the original collage.

There are also screenprint-collages, produced by adding precut collage elements to a silkscreen print. A familiar example is *Carolina Blue* (1970, signed edition of 100) based on the collage of the same title (1968, Collection Bearden Estate).

Bearden also replicated the same image in various media. For example, the "Prevalence of Ritual" paintings (1972 and 1973) are reproduced in a silkscreen portfolio of the same title (1974, five prints, edition of 100). Other collage images are *Odysseus* (1977), silkscreen portfolio of same title (1979, five prints, deluxe edition of 75 and regular edition of 125); *Mysteries* (1964), color etching titled *The Train* (1975 edition of 125, deluxe edition of 25); *The Family* (1970), color etching of same title (1969); and *Prevalence of Ritual: Baptism* (1964), silkscreen, same title (1975, deluxe edition of five and regular edition of 50).

42. Romare Bearden, "Artist's Statement," in *Six Panels on a Southern Theme* (Waitsfield, Vermont: Bundy Art Gallery, 1967).

SELECTED BIBLIOGRAPHY

Ashton, Dore. "Romare Bearden, Projections." *Quadrum* (Brussels) 17 (1965):99–110.

Bearden, Paintings and Water Colors Inspired by Garcia Lorca's "Lament for a Bullfighter." New York: Samuel M. Kootz Gallery, 1946.

Bearden, Romare. "Rectangular Structure in My Montage Paintings." *Leonardo*, 2 (1969):11–19.

Bearden, Romare, and Carl Holty. *The Painter's Mind, A Study of the Relations of Structure and Space in Painting.* New York: Crown, 1969.

Bearden, Romare, and Derek Walcott. *The Caribbean Poetry of Derek Walcott and The Art of Romare Bearden.* New York: Farrar, Straus, and Giroux, Inc., 1983.

Berman, Avis. "Romare Bearden, 'I Paint Out of the Tradition of the Blues'." *Art News*, 79 (December 1980):60–66.

Breen, Nelson E., ed. "To Hear Another Language: A Conversation with Alvin Ailey, James Baldwin, Romare Bearden, and Albert Murray." *Callaloo No. 40*, 12 (Summer 1989):431–52.

Brenson, Michael. "Romare Bearden: Epic Emotion, Intimate Scale." *The New York Times*, March 27, 1988; pp. 40–41, 43.

Caldwell, Bill. "Romare Bearden." *Essence* (May 1975):70–73.

Campbell, Mary S. "Romare Bearden: Rites and Riffs." *Art in America* (December 1981):134–42.

Campbell, Mary S. "Romare Bearden: A Creative Mythology." Ph.D. dissertation. New York: Syracuse University, 1982.

Childs, Charles. "Bearden: Identification and Identity." *Art News* 63 (October 1964):24, 54, 61.

Dover, Cedric. *American Negro Art.* New York: New York Graphic Society, 1960.

Driskell, David. *Two Centuries of Black American Art.* Los Angeles County Museum of Art, and New York: Alfred A. Knopf, 1976.

Ellison, Ralph. "Romare Bearden: Paintings and Projections." *The Crisis* 77 (March 1970):80–86.

Ellison, Ralph. "Romare Bearden." *Callaloo No. 36* (Summer 1988):416–19.

Fax, Elton C. *Seventeen Black Artists.* New York: Dodd, Mead & Co., 1971.

Locke, Alain, ed. *The Negro In Art.* New York: Hacker Art Books, reprint, 1968. First printing, 1940.

Mysteries: Women in the Art of Romare Bearden. Syracuse, New York: Everson Museum of Art of Syracuse and Onondaga County, 1975.

New Names in American Art. Washington, D.C.: The G Place Gallery, 1944.

New Paintings by Bearden. New York: Samuel M. Kootz Gallery, 1944.

Romare Bearden, Oils, Gouaches, Water Colors, Drawings, 1937–1940. New York: 306 West 141st Street, 1940.

Romare Bearden: Paintings and Projections. Albany, New York: The Art Gallery, State University of New York, 1968.

Romare Bearden: The Prevalence of Ritual. New York: The Museum of Modern Art, 1971.

Romare Bearden 1970–1980. Charlotte, N.C.: The Mint Museum. 1980.

Romare Bearden: Origins and Progressions. Michigan: The Detroit Institute of Arts, 1986.

Romare Bearden, 1911–1988, A Memorial Exhibition. New York: ACA Galleries, 1988.

Schwartzman, Myron. "Of Mecklenburg, Memory, and the Blues: Romare Bearden's Collaboration with Albert Murray." *Bulletin of Research in the Humanities* (Summer 1983):140–61.

Schwartzman, Myron. "A Bearden-Murray Interplay: One Last Time." *Callaloo No. 36* 11 (Summer 1988):410–15.

Sims, Lowery S. "The Unknown Romare Bearden." *Art News* (October 1986): 116–120.

Ten Hierographic Paintings by Sgt. Romare Bearden. Washington, D.C.: The G Place Gallery, 1944.

Tomkins, Calvin. "Putting Something Over Something Else." *The New Yorker* (November 8, 1977):53–58.

Washington, Bunch M. *The Art of Romare Bearden: The Prevalence of Ritual.* New York: Harry N. Abrams, Inc., 1973.

Witkovsky, Matthew S. "Experience vs. Theory: Romare Bearden and Abstract Expressionism." *Black American Literature Forum* 23 (Summer 1989):257–82.

ROMARE BEARDEN
BIOGRAPHY

Born September 2, 1912
Died March 12, 1988

Education

New York University (B.S.), 1935
Art Students League, 1937–1938
Sorbonne, Paris, 1950–51

Selected Solo Exhibitions

Corcoran Gallery, Washington, D.C., 1966
Carnegie Institute, Pittsburgh, Pennsylvania, 1966
Bundy Art Gallery, Waitesfield, Vermont, 1966
Albany Museum, State University of New York, 1968
The Museum of Modern Art, New York, 1971
 (Traveling Exhibition)
Everson Museum, Syracuse, New York, 1975
Mint Museum, Charlotte, North Carolina, 1981
 (Traveling Exhibition)
Birmingham Museum of Art, Birmingham, Michigan, 1982
Detroit Institute of Arts, Detroit, Michigan, 1986
 (Traveling Exhibition)
The North Carolina Museum of Art, Raleigh, North Carolina, 1988

Public Collections

Albright-Knox Art Gallery, Buffalo, New York
Akron Art Institute, Akron, Ohio
Amistad Research Center, New Orleans, Louisiana
Arkansas Art Center, Little Rock, Arkansas
The Art Institute of Chicago, Chicago, Illinois
The Brooklyn Museum, New York
The Butler Institute of American Art, Youngstown, Ohio
Bryn Mawr College, Bryn Mawr, Pennsylvania
The Carnegie Museum of Art, Pittsburgh, Pennsylvania
Carl Van Vechten Gallery of Fine Arts, Fisk University, Nashville, Tennessee
Clark Atlanta University, Atlanta, Georgia

Cleveland Museum of Art, Cleveland, Ohio
Crocker Art Museum, Sacramento, California
Davidson College Art Gallery, Davidson, North Carolina
Detroit Institute of Arts, Detroit, Michigan
Flint Institute of Arts, Flint, Michigan
Greenville County Museum of Art, Greenville, South Carolina
Hampton University Museum, Hampton, Virginia
High Museum of Art, Atlanta, Georgia
Hirshhorn Museum and Sculpture Garden, Smithsonian Institution,
 Washington, D.C.
Honolulu Academy of Art, Honolulu, Hawaii
Howard University Gallery of Art, Washington, D.C.
Madison Art Center, Madison, Wisconsin
Memorial Art Gallery of the University of Rochester, Rochester, New York
The Metropolitan Museum of Art, New York
Mint Museum, Charlotte, North Carolina
Mount Holyoke College Art Museum, South Hadley, Massachusetts
Munson-William-Proctor Institute, Museum of Art, Utica, New York
Museum of Fine Arts, Boston, Massachusetts
The Museum of Modern Art, New York
National Museum of American Art, Smithsonian Institution, Washington, D.C.
Neuberger Museum, State University of New York at Purchase, New York
The Newark Museum, Newark, New Jersey
Philadelphia Museum of Art, Philadelphia, Pennsylvania
Princeton University Art Gallery, Princeton, New Jersey
The St. Louis Art Museum, St. Louis, Missouri
Schomburg Center for Research in Black Culture, The New York
 Public Library, New York
Spelman College, Atlanta, Georgia
The Studio Museum in Harlem, New York
Tougaloo College, Tougaloo, Mississippi
Wadsworth Atheneum, Hartford, Connecticut
Whitney Museum of American Art, New York
University Art Museum, Berkeley, California
University of Oklahoma Museum of Art, Norman, Oklahoma

Honors and Awards

Honorary Doctorate, Pratt Institute, New York, 1973
Honorary Doctorate, Carnegie-Mellon University, Pittsburgh, Pennsylvania,
 1975
Honorary Doctorate, Maryland Institute of Art, Baltimore, Maryland, 1977
Honorary Doctorate, North Carolina Central University, Durham,
 North Carolina, 1977
Honorary Doctorate, Davidson College, Davidson, North Carolina, 1978
Medal of State of North Carolina: For Art, 1976
Honorary Citizen of Atlanta, Georgia, by Proclamation of Mayor Maynard
 Jackson at unveiling of Mural (now destroyed) on the Country Building in
 Atlanta, 1976
Frederick Douglass Medal, New York Urban League, 1978
James Weldon Johnson Award, NAACP, Atlanta Chapter, 1978
Member of the American Academy of Arts and Letters and The National
 Institute of Arts and Letters, 1966
Member of the Board of New York State Council on the Arts
National Medal of Arts, 1987

EXHIBITION CHECKLIST

Dimensions denote unframed measurements unless noted otherwise; height precedes width. All dates are attributed. All works signed "Romare Bearden" unless noted otherwise.

1. *Interior* 1939
 Watercolor on paper; 14 × 22″
 The Carl Van Vechten Gallery of Fine Arts
 Fisk University, Nashville, Tennessee
 Provenance: Harmon Foundation
 (Fig. 3)

2. *Anderson's Materials* ca. 1939
 Watercolor on paper; 17¼ × 24½″
 Signed: lower left, "Bearden"
 The Amistad Research Center
 New Orleans, Louisiana
 Provenance: Aaron Douglas
 (Fig. 4)

3. *Two Women in a Landscape* ca. 1941
 Tempera on paper on board; 31½ × 48″
 Collection Aida Bearden Winters, New
 York
 Provenance: From the artist
 Charles Alston Estate
 (Fig. 5)

4. *Resurrection* 1945
 Oil on board; 48 × 36″
 Signed: lower left, "Bearden"
 Collection Duke Ellington Family,
 Ruth Ellington Boatwright
 and Steven and Allison James, New York
 Provenance: Duke Ellington, 1945
 (Fig. 6)

5. *Madonna and Child* 1945
 Oil on canvas; 38 × 30″
 Signed: upper right, "R. Bearden"
 Bryn Mawr College, Bryn Mawr,
 Pennsylvania
 Gift of Roy R. Neuberger
 (Fig. 7)

6. *Last Supper* 1945
 Watercolor, ink on paper; 17 × 23″
 Signed: bottom right, "R. Bearden"
 The Carl Van Vechten Gallery of Fine Arts
 Fisk University, Nashville, Tennessee
 Provenance: Mr. Barry Ulanov, New York

7. *He Is Arisen* 1945
 Watercolor, ink on paper; 26 × 19⅜″
 Signed: top left, "Bearden"
 The Museum of Modern Art, New York
 Advisory Committee Fund
 Provenance: Samuel M. Kootz Gallery
 (Plate I)

8. *Golgotha* 1945
 Watercolor, ink on paper; 19⅞ × 25¼″
 Signed: lower right, "Bearden"
 The Metropolitan Museum of Art, New
 York
 Bequest of Margaret S. Lewisohn, 1954
 Provenance: Samuel M. Kootz Gallery
 Samuel A. Lewisohn, New
 York, 1945

9. *Adoration of the Wise Men* 1945
 Oil on masonite; 22¼ × 28⅛″
 Signed: upper left, "Bearden"
 The Newark Museum, Newark, New Jersey
 Gift of Mr. and Mrs. Benjamin E. Tepper,
 1946

10. *Madonna and Child* 1945
 Oil on canvas; 38¼ × 30″
 Signed: upper right, "Bearden"
 Collection Morgan and Marvin Smith, New
 York
 Provenance: From the artist
 (Fig. 8)

11. *Five in the Afternoon* 1946
 Oil on composition board; $39\frac{1}{2} \times 47\frac{1}{4}''$
 Signed: upper right, "Bearden"
 University of Oklahoma Museum of Art,
 Norman, Oklahoma
 Provenance: War Assets Administration,
 1948
 (Fig. 9)

12. *Even the Sea Dies* 1946
 Oil and sand on canvas; $24 \times 20''$
 Signed: upper right, "Bearden"
 Collection Morgan and Marvin Smith, New
 York
 Provenance: From the artist
 (Fig. 10)

13. *Secret Voices* 1946
 Watercolor and ink on paper; $20\frac{1}{2} \times 26\frac{3}{4}''$
 Signed: lower left, "Bearden"
 Private collection, New York
 Provenance: From the artist
 Note: title not on original exhibition check-
 list

14. *Who Creases the Shroud* 1946
 Watercolor and ink on paper; $20\frac{1}{2} \times 26\frac{3}{4}''$
 Signed: lower left, "Bearden"
 Private collection, New York
 Provenance: From the artist

15. *You Are Dead Forever* 1946
 Watercolor and ink on paper; $20\frac{1}{2} \times 26\frac{3}{4}''$
 Signed: upper right, "Bearden"
 Private collection, New York
 Provenance: From the artist
 (Plate II)

16. *Spilled on the Sand* 1946
 Watercolor and ink on paper; $20\frac{1}{2} \times 26\frac{3}{4}''$
 Signed: lower left, "Bearden"
 Private collection, New York
 Provenance: From the artist
 Note: title not on original exhibition check-
 list

17. *The Horns Near* 1946
 Watercolor and ink on paper; $20\frac{1}{2} \times 26\frac{3}{4}''$
 Signed: lower left, "Bearden"
 Private collection, New York
 Provenance: From the artist

18. *What a Great Torero in the Ring* 1946
 Watercolor and ink on paper; $20\frac{1}{2} \times 26\frac{3}{4}''$
 Signed: lower right, "Bearden"

Private collection, New York
Provenance: From the artist
(Fig. 11)

19. *The Bull of Guisando* 1946
 Watercolor and ink on paper; $20\frac{1}{2} \times 26\frac{3}{4}''$
 Signed: lower right, "Bearden"
 Private collection, New York
 Provenance: From the artist

20. *Two Figures* ca. 1946
 Oil on masonite; $22 \times 30''$
 Signed: lower left, "Bearden"
 Collection R. L. Lewis, New York
 Courtesy Larry Randall Galleries, Ltd.,
 New York
 Provenance: From the artist
 Charles Alston Estate
 Larry Randall Galleries
 (Plate III)
 Subject suggests work was exhibited in "The
 Big Top" (Kootz Gallery, March 1946);
 therefore the work dates no later than
 1946.

21. *The Blues Has Got Me* ca. 1946
 Watercolor and ink on paper; $19\frac{1}{2} \times 25\frac{7}{8}''$
 Signed: upper right, "Bearden"
 Collection Dr. Walter O. Evans, Detroit,
 Michigan
 Provenance: Selden Rodman, New York
 (Fig. 12)

22. *Woman Seated on Rock* 1947
 Watercolor and ink on paper; $24 \times 28''$
 Signed: upper right, "Bearden"
 Private collection, New York
 Provenance: From the artist
 On the verso is *Christ Washing the Feet of His
 Disciples*
 (Fig. 13)

23. *Seated Female* ca. 1947
 Watercolor on paper; $18\frac{1}{2} \times 24''$
 Signed: upper right
 Collection Morgan and Marvin Smith, New
 York
 Provenance: From the artist
 (Fig. 14)

24. *Two Women in a Courtyard* ca. 1948
 Watercolor and ink on paper; $24 \times 18''$
 Signed: lower right, "Bearden"
 Collection June Kelly, New York

Provenance: Martin Diamond Fine Arts, New York

(Fig. 15)

25. *Two Standing Figures* ca. 1948
Watercolor and ink on paper; 26 × 20"
Signed: top right, "Romare Bearden" (ink)
 top left, "Bearden" (graphite)
Private collection, New York
Provenance: From the artist

26. *The Blue Lady* 1955
Oil on canvas; 41½ × 32½"
Signed: lower left
Private collection, New York
Provenance: From the artist
(Plate IV)

27. *Mountains of the Moon* 1956
Oil on canvas; 40½ × 31¾"
Signed: top left; dated, titled, and signed on verso by artist
Private collection, New York
Provenance: From the artist

28. *The Mirror* ca. 1959
Oil on linen; 39¼ × 29½"
Signed: top left
Private collection, New York
Provenance: From the artist

29. *Silent Valley of Sunrise* 1959
Oil and casein on canvas; 58⅛ × 42"
Signed: upper left
The Museum of Modern Art, New York
Anonymous gift, 1960
Provenance: Michael Warren Gallery, New York

30. *Snow Morning* ca. 1959
Oil on canvas; 56½ × 45"
Signed: upper left
Clark Atlanta University Collection, Atlanta, Georgia
Gift of Chauncey and Catherine Waddell, Atlanta

31. *Winds of Spring* ca. 1960
Oil on canvas; 57½ × 45"
Signed: lower right
Collection Mrs. James Dugan, Philadelphia, Pennsylvania
Provenance: From the artist

32. *Blue Is the Smoke of War, White the Bones of Men* ca. 1960
Acrylic on canvas; 66⅛ × 52⅛"
Signed: upper left
Collection Beatrice and Harry Henderson, Croton-on-Hudson, New York
Provenance: From the artist
(Plate VI)

33. *Old Poem* 1960
Oil on linen; 25 × 32"
Signed: upper left, titled, dated on verso by artist
Private collection, New York
Provenance: From the artist
(Plate V)

34. *Mysteries* 1964
Photoprojection; 21⅝ × 21½"
Collection Dr. Beny Primm, New York
Provenance: From the artist

35. *Mysteries* 1964
Photomontage on board; 11¼ × 14¼"
The Museum of Fine Arts, Boston, Ellen Kelleran Gardner Fund
Provenance: Cordier & Ekstrom, Inc., New York, 1971

36. *The Dove* 1964
Collage and mixed media on board; 13⅜ × 18¾"
The Museum of Modern Art, New York
Blanchette Rockefeller Fund
Provenance: Cordier & Ekstrom, Inc., New York
 Jeanne Siegel, New York
(Fig. 16)

37. *Pittsburgh Memory* 1964
Photomontage on board; 9¼ × 11¾"
Signed: center right on verso
Collection Gladys and Russell Williams, New York
Provenance: Cordier & Ekstrom, Inc., New York

38. *Cotton* 1964
Photomontage and mixed media on board; 11⅛ × 14"
Signed: bottom left
Hirshhorn Museum and Sculpture Garden, Smithsonian Institution, Washington, D.C.
Gift of Joseph H. Hirshhorn, 1966
(Fig. 17)

39. *Watching the Good Trains Go By* 1964
Photomontage and mixed media on board;
9³/₄ × 12″
Collection Philip J. and Suzanne Schiller,
American Social Commentary Art 1930–
1970, Highland Park, Illinois
Provenance: Cordier & Ekstrom, Inc., New
York
(Plate VII)

40. *Uptown Looking Downtown* 1964
Photoprojection; 28 × 37″
Collection Richard V. Clarke, New York
Provenance: From the artist

41. *Prevalence of Ritual: Conjur Woman* 1964
Photomontage and mixed media on board;
12¹/₂ × 9³/₈″
The Museum of Modern Art, New York
Blanchette Rockefeller Fund
Provenance: Cordier & Ekstrom, Inc., New
York
Jeanne Siegel, New York

42. *Prevalence of Ritual: Conjur Woman* 1964
Photoprojection on board; 64 × 49⁷/₈″
The Studio Museum in Harlem, New York
Provenance: From the artist
(Fig. 18)

43. *Prevalence of Ritual: Conjur Woman as an Angel* 1964
Photomontage and mixed media on board;
9¹/₂ × 6¹/₂″
Collection Ann Feinberg, New York
Provenance: Cordier & Ekstrom, Inc., New
York
Douglas Newton, New York
Merton Simpsom, New York
(Fig. 20)

44. *Jazz (Chicago) Grand Terrace Ballroom—1930s* 1964
Collage and mixed media on board;
49¹/₂ × 68¹/₂″
Howard University Gallery of Art,
Washington, D.C.
Provenance: From the artist, 1972
(Fig. 21)

45. *Evening: 9:10; 417 Lenox Avenue* 1964
Collage and mixed media on board;
8¹/₂ × 11¹/₈″
Davidson College Art Gallery, Davidson,
North Carolina

Provenance: Cordier & Ekstrom, Inc., New
York
(Plate VIII)

46. *Prevalence of Ritual: Baptism,* 1964
Collage and mixed media on board;
9 × 11⁷/₈″
Signed: bottom left
Hirshhorn Museum and Sculpture Garden,
Smithsonian Institution, Washington,
D.C.
Gift of Joseph H. Hirshhorn, 1966
(Fig. 22)

47. *Sermons: The Walls of Jericho* 1964
Collage and mixed media on board;
11⁷/₈ × 9³/₈″
Hirshhorn Museum and Sculpture Garden,
Smithsonian Institution, Washington,
D.C.
Gift of Joseph H. Hirshhorn, 1966
(Fig. 23)

48. *Conjur Woman* 1964
Collage and mixed media on board;
9¹/₄ × 7¹/₄″
Signed: top left, "Romare"
Collection Sheldon Ross, Huntington
Woods, Michigan
Provenance: J. L. Hudson Gallery, Detriot,
Michigan, 1967
(Fig. 19)

49. *Woman* 1965
Collage and mixed media on board;
36 × 23⁷/₈″
Signed: upper right
Courtesy Sid Deutsch Gallery, New York
Provenance: From the artist
(Fig. 24)

50. *Pittsburgh* 1965
Photomontage and mixed media on board;
6³/₈ × 9³/₄″
Signed: lower right
Collection Beatrice and Harry Henderson,
Croton-on-Hudson, New York
Provenance: From the artist
(Fig. 25)

51. *Farmhouse Interior* 1965
Collage and mixed media on board;
9⁵/₈ × 12¹/₂″
Signed: lower right

Collection Sheldon Ross, Huntington
Woods, Michigan
Provenance: J. L. Hudson Gallery, Detroit,
Michigan, 1967
(Fig. 26)

52. *La Primavera* 1967
Collage and mixed media on board;
8³/₈ × 13¹/₈"
Signed: upper left
Private collection
Courtesy Sheldon Ross Gallery,
Birmingham, Michigan
Provenance: J. L. Hudson Gallery, Detroit,
Michigan, 1967
Chauncey L. Waddell, New
York
Sheldon Ross Gallery, 1986
(Fig. 27)

53. *Summer Song* 1967
Collage and mixed media on board;
39¹/₂ × 29¹/₂"
Signed: lower right
Courtesy Sid Deutsch Gallery, New York
Provenance: Wilder Green, New York
(Plate IX)

54. *Three Folk Musicians* 1967
Collage and mixed media on canvas;
50¹/₈ × 60"
Signed: top left
Private collection
Courtesy Sheldon Ross Gallery, Bir-
mingham, Michigan
Provenance: J. L. Hudson Gallery, Detroit,
Michigan, 1967
Andrew Crispo Gallery, New
York
Sheldon Ross Gallery, 1987
(Plate X)

55. *Melon Season* 1967
Collage and mixed media on canvas;
56 × 44"
Signed: upper right
The Neuberger Museum, State University
of New York at Purchase, New York
Gift of Roy R. Neuberger
(Fig. 28)

56. *Rites of Spring* 1967
Collage and mixed media on canvas;
55³/₄ × 44"
Signed: top left
Collection R. L. Lewis, New York

Provenance: Cordier & Ekstrom, Inc., New
York
Carter Burden, New York
Sid Deutsch Gallery, New
York, 1986
(Fig. 29)

57. *Guitar Executive* 1967
Collage, and mixed media on board; 56 ×
44"
Signed: upper right
Spelman College, Atlanta, Georgia
Provenance: Cordier & Ekstrom, Inc., New
York, 1967
(Fig. 30)

58. *Return of the Prodigal Son* 1967
Collage and mixed media on canvas;
44 × 56"
Signed: upper right
Albright-Knox Art Gallery, Buffalo, New
York
Gift of Mr. and Mrs. Armand J. Castellani,
New York
Provenance: Cordier & Ekstrom, Inc., New
York
J. L. Hudson Gallery, Detroit,
Michigan
Private collection, New York,
1967
Adrian Art, New York 1973
Mr. and Mrs. A. J. Castellani,
Niagara Falls, New York,
1981
(Fig. 31)

59. *La Primavera* 1967
Collage and mixed media on board;
44 × 56"
Signed: lower right
Collection Philip J. and Suzanne Schiller,
American Social Commentary Art 1930–
1970, Highland Park, Illinois
Provenance: Edgar C. Schenck, New York
(Plate XI)

60. *Family* 1967/68
Collage and mixed media on canvas;
56 × 44"
Signed: lower left
The Museum of Fine Arts, Boston,
Massachusetts
Abraham Shuman Fund
Provenance: Cordier & Ekstrom, Inc., New
York, 1971
(Fig. 32)

61. *Two Women* 1968
 Collage and mixed media on canvas;
 44 × 56″
 Signed: top right
 Courtesy Sid Deutsch Gallery, New York
 Provenance: Cordier & Ekstrom, Inc., New
 York
 Private collection
 (Fig. 35)

62. *Eastern Barn* 1968
 Collage and mixed media on board;
 55½ × 44″
 Signed: top left
 The Whitney Museum of American Art,
 New York
 Provenance: Cordier & Ekstrom, Inc., New
 York
 (Fig. 33)

63. *Mother and Child* 1968
 Collage and mixed media on board;
 39⅞ × 29⅞″
 Signed: top left
 Crocker Art Museum, Sacramento,
 California
 Gift of the Crocker Art Gallery Association
 with matching funds from the National
 Endowment for the Arts
 Provenance: Cordier & Ekstrom, Inc., New
 York
 (Fig. 34)

64. *Blue Interior; Morning* 1968
 Collage and mixed media on board;
 44 × 56″
 Signed: upper right
 Collection The Chase Manhattan Bank,
 N. A., New York
 Provenance: Cordier & Ekstrom, Inc., New
 York

65. *Courtyard Sky* 1968
 Collage on board; 18½ × 14½″
 Signed: upper left
 Collection Jane and David Shapiro,
 Washington, D.C.
 Provenance: Cordier & Ekstrom, Inc., New
 York
 Sarah Shapiro
 (Fig. 36)

66. *Serenade* 1968/69
 Collage and mixed media on board;
 45¾ × 32½″

Signed: top right
The Madison Art Center, Milwaukee,
 Wisconsin
Provenance: Cordier & Ekstrom, Inc., New
 York
 Jacques Kaplan, New York
(Plate XII)

67. *Black Manhattan* 1969
 Collage on board; 25⅞ × 21″
 Signed: top right
 Schomburg Center for Research in Black
 Culture, Art and Artifacts Division,
 The New York Public Library
 Provenance: Mr. and Mrs. Theodore
 Kheel, New York
 (Fig. 38)

68. *Black Madonna and Child* 1969
 Collage and mixed media on board;
 24¹³⁄₁₆ × 16¾″
 Signed: top left
 Hirshhorn Museum and Sculpture Garden,
 Smithsonian Institution, Washington,
 D.C.
 Bequest of Joseph H. Hirshhorn, 1981
 (Fig. 40)

69. *Continuities* 1969
 Collage and mixed media on board;
 50 × 40″
 Signed: lower left
 The University Art Museum, Berkeley,
 California
 Gift of the Childe Hassam Fund of the
 American Academy of Arts and Letters
 Provenance: Cordier & Ekstrom, Inc., New
 York
 (Fig. 37)

70. *Patchwork Quilt* 1969
 Collage on board; 9 × 11⅞″
 Signed: upper left
 Private collection
 Courtesy Sheldon Ross Gallery,
 Birmingham, Michigan
 Provenance: Cordier & Ekstrom, Inc., New
 York
 Helen M. Harding, New York
 Sheldon Ross Gallery, 1987
 (Plate XIII)

71. *Blue Monday* 1969
 Collage on board; 12 × 19″
 Signed: top left
 Private collection

Courtesy Sheldon Ross Gallery, Birmingham, Michigan
Provenance: Cordier & Ekstrom, Inc., New York
 Helen M. Harding, New York
 Sheldon Ross Gallery, 1987
(Fig. 39)

72. *Reclining Nude* ca. 1970
Collage and mixed media on board;
 $11^{1}/_{2} \times 17^{1}/_{2}''$
Signed: upper left
Collection Billie Allen, New York
Provenance: From the artist

73. *Patchwork Quilt* 1970
Collage and mixed media on board;
 $35^{3}/_{4} \times 47^{7}/_{8}''$
Signed: upper right
The Museum of Modern Art, New York
Blanchette Rockefeller Fund, 1970
Provenance: Cordier & Ekstrom, Inc., New York

74. *Hometime* 1970
Collage and mixed media on board;
 $26^{1}/_{2} \times 45^{1}/_{2}''$
Signed: lower left
Butler Institute of American Art, Youngstown, Ohio
Provenance: Andrew Crispo Gallery, New York
 Dr. Samuel S. Mandel, New York
(Fig. 42)

75. *She-Ba* 1970
Collage on board; $48 \times 35^{7}/_{8}''$
Signed: top left
Wadsworth Atheneum, Hartford, Connecticut
Ella Gallup Sumner and Mary Catlin Sumner Collection
(Fig. 41 / cover)

76. *Young Students* ca. 1970
Collage on board; $15^{1}/_{2} \times 24''$
Signed: lower right
Collection Peg Alston, New York
Provenance: From the artist

77. *Carolina Interior* 1970
Collage and mixed media on board;
 $13^{1}/_{8} \times 16^{1}/_{8}''$
Signed: upper left

Private collection, Michigan
Provenance: Shorewood Publishers
 Karl and Faber Auction House, Munich, West Germany
 Sheldon Ross Gallery
(Fig. 43)

78. *The Witnesses* 1970
Collage and mixed media on board;
 $16 \times 21''$
Signed: top left
CIBA-GEIGY Corporation, Ardsley, New York
Provenance: Cordier & Ekstrom, Inc., New York, 1970
(Fig. 44)

79. *The Block* 1971
Collage and mixed media on board, 6 panels: $48 \times 216''$
Signed: (each panel, left to right): top right, top right
 top right, top left, bottom left, bottom left
The Metropolitan Museum of Art, New York
Gift of Mr. and Mrs. Samuel Shore, 1978
Provenance: Shorewood Publishers, New York
(Fig. 45)

80. *Untitled* ca. 1971
Collage and mixed media on board;
 $11^{1}/_{2} \times 15^{1}/_{2}''$
Collection Rowan Khaleel, New York
Courtesy Peg Alston Fine Arts, New York
Provenance: From the artist
(Fig. 46)

81. *Battle with the Cicones* ca. 1972
Watercolor on paper; $9^{1}/_{4} \times 12^{3}/_{4}''$
Signed: lower left
Private collection, New York
(Fig. 47)

82. *Poseidon, The Sea God* ca. 1972
Watercolor on paper; $17 \times 12^{3}/_{4}''$
Signed: lower right
Private collection, New York

83. *Scylla and Charybdis* ca. 1972
Watercolor on paper; $5^{3}/_{4} \times 6^{3}/_{8}''$
Signed: upper right
Private collection, New York

84. *The Land of the Lotus Eaters* ca. 1972
Watercolor on paper; $8^7/_8 \times 2^3/_4''$
Signed: upper left
Private collection, New York

85. *The Departure from Troy* ca. 1972
Watercolor on paper; $6 \times 8^{11}/_{16}''$
Signed: lower right
Private collection, New York
(Fig. 49)

86. *Odysseus Leaves Circe* ca. 1972
Watercolor on paper; $6 \times 8^1/_2''$
Signed: upper right
Private collection, New York
(Fig. 48)

87. *Noah, Third Day* 1972
Collage and mixed media on board;
$40^1/_2 \times 35^1/_2''$
Signed: upper left
High Museum of Art, Atlanta, Georgia
Gift in Memory of Peter Rindskopf and
Museum Purchase
Provenance: Cordier & Ekstrom, Inc., New
York
(Fig. 51)

88. *Prologue to Troy No. 2* 1972
Collage and mixed media on board;
$55^1/_2 \times 45^1/_2''$
Signed: upper left
Courtesy ACA Galleries, New York
Provenance: Cordier & Ekstrom, Inc., New
York
Dr. Samuel S. Mandel, New
York
(Fig. 52)

89. *Reverend John's Sermon No. 1* 1973
Collage and mixed media on board;
$56 \times 46''$
Signed: lower right
Flint Institute of Arts, Flint, Michigan
Provenance: Cordier & Ekstrom, Inc., New
York, 1973
(Plate XV)

90. *New Orleans Farewell* 1974
Collage and mixed media on board;
$44 \times 50''$
Signed: upper right
Private collection, New York
Provenance: Cordier & Ekstrom, Inc., New
York

91. *At Connie's Inn* 1974
Collage and mixed media on board;
$49^7/_8 \times 39^7/_8''$
Signed: lower left
The Brooklyn Museum, New York
Provenance: Cordier & Ekstrom, Inc., New
York
(Plate XVI)

92. *Carolina Shout* 1974
Collage and mixed media on board;
$37^1/_2 \times 51''$
Signed: lower right
Mint Museum of Art, Charlotte, North
Carolina
Museum purchase, Charlotte Debutante
Club Fund and National Endowment for
the Arts Matching Fund
Provenance: Cordier & Ekstrom, Inc., New
York
(Fig. 53)

93. *The Fall of Troy* 1974
Collage on board; $36 \times 48''$
Signed: upper right
Collection Dr. Florence Ladd, Cambridge,
Massachusetts
Provenance: Cordier & Ekstrom, Inc., New
York
(Fig. 50)

94. *The Street* 1975
Collage on board; $37^1/_2 \times 51''$
Signed: upper right
Private collection
Courtesy Sheldon Ross Gallery, Birming-
ham, Michigan
Provenance: Sheldon Ross Gallery
Private collection, Michigan,
1977
(Fig. 54)

95. *Conjur Woman* 1975
Collage on board; $46 \times 36''$
Signed: center right
Private collection
Courtesy Sheldon Ross Gallery, Birming-
ham, Michigan
Provenance: Sheldon Ross Gallery
Private collection, 1977
(Fig. 55)

96. *Madame's White Bird* 1975
Collage and mixed media on board;
$13 \times 15''$

Signed: lower right
Collection Jane and David Shapiro, Washington, D.C.
Provenance: From the artist
(Fig. 56)

97. *Indigo Snake* 1975
Collage and watercolor on paper; 30 × 23″
Signed: lower right
The Freedom Place Collection, Washington, D.C.
Provenance: From the artist, 1976
(Fig. 57)

98. *Morning of Red Bird* 1975
Collage and mixed media on board;
16½ × 21″
Signed: lower right
The Freedom Place Collection, Washington, D.C.
Provenance: From the artist
(Plate XVII)

99. *The Visitor* 1976
Collage on board; 18 × 24″
Signed: bottom left
Collection Mr. and Mrs. Richard Doerer, Grosse Pointe, Michigan
Courtesy Sheldon Ross Gallery, Birmingham, Michigan
Provenance: Sheldon Ross Gallery
 Dr. Clarence P. Rogers, 1977
 Sheldon Ross Gallery, 1990
(Fig. 58 / Plate XIV)

100. *Southern Limited* 1976
Collage and mixed media on board;
18 × 24″
Signed: center left
Private collection
Courtesy Sheldon Ross Gallery, Birmingham, Michigan
Provenance: Sheldon Ross Gallery
 Private Collection, 1980
(Fig. 59)

101. *Electric Evening* 1976
Collage and mixed media on board;
18 × 24″
Signed: center left
Collection Mr. and Mrs. Sam Pearlstein, Southfield, Michigan
Courtesy Sheldon Ross Gallery, Birmingham, Michigan

Provenance: Sheldon Ross Gallery
 Mr. and Mrs. Pearlstein, 1976
(Fig. 61)

102. *Dream Images* 1976
Collage; 11³/₈ × 14¹/₈″
Signed: upper right
Private collection
Courtesy Sheldon Ross Gallery, Birmingham, Michigan
Provenance: Sheldon Ross Gallery
 Private collection, 1978
(Fig. 61)

103. *Hidden Valley* 1976
Photomontage and watercolor on board;
18 × 24″
Signed: lower right
Dr. and Mrs. Harold Plotnick, Franklin, Michigan
Courtesy Sheldon Ross Gallery, Birmingham, Michigan
Provenance: Sheldon Ross Gallery
 Dr. and Mrs. H. Plotnick, 1976
(Fig. 62)

104. *The Sea Nymph* 1977
Collage and mixed media on board;
44 × 32″
Signed: upper left
Private collection, New York
Provenance: Cordier & Ekstrom, Inc., New York, 1977
(Fig. 63)

105. *Living Room* 1978
Collage and mixed media on board;
6½ × 8½″
Signed: center right, "Bearden"
Collection Sheldon Ross, Huntington Woods, Michigan
Provenance: Sheldon Ross Gallery
 Sheldon Ross, 1979
(Fig. 64)

106. *Prevalence of Ritual: Conjur Woman as an Angel* 1978
Collage on board; 7½ × 5¼″
Signed: lower left
Collection Dr. Florence Ladd, Cambridge, Massachusetts
Provenance: Cordier & Ekstrom, Inc., New York

107. *Evening* 1978

Watercolor on paper; $8^{1}/_{2} \times 6''$
Signed: lower left
Private collection
Courtesy Sheldon Ross Gallery, Birming-
ham, Michigan
Provenance: Sheldon Ross Gallery
Dr. Clarence P. Rogers, 1979
Sheldon Ross Gallery, 1990
(Fig. 65)

108. *Pittsburgh* 1978
Watercolor and collage on board;
$6^{1}/_{2} \times$
$8^{1}/_{2}''$
Signed: upper left
Collection Dr. and Mrs. S. Nagel, South-
field, Michigan
Provenance: Sheldon Ross Gallery,
Birmingham, Michigan
Dr. and Mrs. S. Nagel, 1979
(Fig. 66)

109. *Sunset Limited* 1978
Collage and mixed media on board;
$15^{1}/_{2} \times 20^{1}/_{4}''$
Signed: upper right
Collection Ute and Gerhard Stebich,
Plainfield, Massachusetts
Provenance: From the artist
(Plate XVIII)

110. *Maudell Sleet's Magic Garden* 1978
Collage on board; $10^{1}/_{8} \times 7''$
Signed: upper right
Collection Linda and Person Cummin III,
Greenwich, Connecticut
Provenance: From the artist
Mr. and Mrs. Gerhard
Stebich, Massachusetts

111. *Miss Bertha and Mr. Seth* 1978
Collage on board; $25^{1}/_{2} \times 18^{1}/_{2}''$
Signed: upper left
Collection Mr. and Mrs. Reuven Merker,
Englewood Cliffs, New Jersey
Provenance: Cordier & Ekstrom, Inc.,
New York
(Fig. 63)

112. *Farewell Eugene* 1978
Collage and mixed media on board;
$16^{1}/_{4} \times 20^{1}/_{2}''$
Signed: upper left
Collection Laura Grosch and Herb Jackson,
Davidson, North Carolina

Provenance: Cordier & Ekstrom, Inc., New
York
Mr. and Mrs. Eugene
Gormam, New York
(Plate XIX)

113. *The Garden* 1978
Watercolor and collage on paper;
$9^{1}/_{2} \times 6^{1}/_{4}''$
Signed: upper right
Private collection
Courtesy Sheldon Ross Gallery, Birming-
ham, Michigan
Provenance: Sheldon Ross Gallery
Dr. Clarence P. Rogers,
Michigan, 1979
Sheldon Ross Gallery, 1990
(Fig. 67)

114. *Miss Bertha and Mr. Seth* 1979
Watercolor on paper; $10 \times 7''$
Signed: upper left
Collection Michael Tolan, New York
Provenance: Sheldon Ross Gallery

115. *Guitar Executive* 1979
Collage and mixed media on board; $9 \times 6''$
Signed: upper right
Collection Herman Binder, Farmington,
Michigan
Courtesy Sheldon Ross Gallery, Birming-
ham, Michigan
Provenance: Sheldon Ross Gallery
Herman Binder, Michigan,
1982
(Fig. 69)

116. *Storyville* 1979
Collage and mixed media on board; $6 \times 9''$
Signed: upper right
Private collection
Courtesy Sheldon Ross Gallery, Birming-
ham, Michigan
Provenance: Sheldon Ross Gallery
Private collection, 1980
(Fig. 70)

117. *Storyville: Red Lady* 1979
Collage and mixed media on board; $6 \times 9''$
Signed: upper left
The Studio Museum in Harlem, New York
Gift of Schenkers International For-
warders, Inc., Connecticut

118. *Untitled (Female Nude)* ca. 1979

Collage and mixed media on paper;
5³/₄ × 8⁵/₈″
Signed: center left
Arkansas Art Center Foundation Collection, Little Rock, Arkansas
Lent by Stephens, Inc., 1982
Provenance: Sotheby's, New York
 Dr. Robert C. Atkins (Libra art Exchange)
 Stephens, Inc., Little Rock, Arkansas
(Fig. 71 / Plate XX)

119. *The White Cat* 1979
Collage on board; 24 × 18″
Signed: lower right
Private collection
Provenance: Sheldon Ross Gallery, Birmingham, Michigan
 Private collection, 1980
(Fig. 72)

120. *Maudell Sleet* ca. 1980
Watercolor and collage on paper;
40¹/₄ × 31⁵/₈″ (framed)
Signed: upper left
Collection E. Boulware, New York
Provenance: From the artist
(Plate XXII)

121. *Two Jazz Musicians* ca. 1980
Watercolor on paper; 22 × 30″
Signed: lower left
Private collection
Courtesy Sheldon Ross Gallery, Birmingham, Michigan
Provenance: Dr. Jack Fein, New York
 Manuel Marin, New York
 Sheldon Ross Gallery, 1988
(Fig. 73

122. *Uptown Manhattan Skyline: Storm Approaching* 1980
Collage and mixed media on board;
40 × 30″
Signed: lower left
Collection Mr. and Mrs. Reuven Merker, Englewood Cliffs, New Jersey
Provenance: Cordier & Ekstrom, Inc., New York, 1981
(Fig. 74)

123. *Artist with Painting and Model* 1981
Collage with mixed media on board;
44 × 56″

Signed: lower left
Private collection, New York
Provenance: Cordier & Ekstrom, Inc., New York, 1981
(Fig. 75)

124. *Prelude to Farewell* 1981
Collage on board; 48 × 36″
Signed: lower left
Philip Morris Companies Inc., New York
Provenance: Cordier & Ekstrom, Inc., New York

125. *Cardplayers* 1982
Collage on board; 18 × 24″
Signed: upper left
Private collection
Courtesy Sheldon Ross Gallery, Birmingham, Michigan
Provenance: Sheldon Ross Gallery
 Private collection, 1982
(Plate XXI)

126. *Madonna and Child* 1982
Collage and watercolor; 5¹/₈ × 3³/₄″
Signed: upper right
Collection Barbara Wallace, Philadelphia, Pennsylvania
Provenance: From the artist

127. *Midtown* 1982
Collage on board; 27³/₄ × 20⁵/₈″
Signed: lower left
Private collection
Courtesy Sheldon Ross Gallery, Birmingham, Michigan
Provenance: Sheldon Ross Gallery
 Private collection, 1983
(Fig. 77)

128. *City Lites* 1982
Watercolor on paper; 19¹/₂ × 13⁷/₈″
Signed: middle right
Private collection
Courtesy Sheldon Ross Gallery, Birmingham, Michigan
Provenance: Sheldon Ross Gallery
 Private collection, 1983
(Fig. 76)

129. *Pittsburgh Memories* 1984
Collage on board; 20⁵/₈ × 23¹/₂″
Signed: lower left
The Carnegie Museum of Art, Pittsburgh, Pennsylvania

Gift of Mr. and Mrs. Ronald R. Davenport
and Mr. and Mrs. Milton A. Washington,
1984
Provenance: Commissioned from the artist
(Fig. 78)

130. *Blue Lady* 1984
Watercolor on paper; 13$^{1}/_{8}$ × 9$^{1}/_{4}$"
Signed: lower right
Private collection
Courtesy Sheldon Ross Gallery, Birming-
ham, Michigan
Provenance: Sheldon Ross Gallery
Private collection, 1984
(Plate XXIV)

131. *Obeah Man with Cigar* 1984
Watercolor on paper; 30 × 22"
Signed: lower right
Private collection
Courtesy Sheldon Ross Gallery, Birming-
ham, Michigan
Provenance: Sheldon Ross Gallery
Private collection, 1985
(Fig. 79)

132. *In a Green Shade* 1984
Collage and watercolor on board; 40 × 30"
Signed: upper left
Collection Estate of William H. Van Every,
Jr., Charlotte, North Carolina
Courtesy of Jerald Melberg Gallery,
Charlotte, North Carolina
Provenance: Jerald Melberg Gallery
(Plate XXIII)

133. *The Lignum Vitae: Cole Bay* 1985
Watercolor on paper; 30 × 22"
Signed: upper right
Collection Herbert Gentry, New York
Provenance: From the artist

134. *Landscape* ca. 1985
Watercolor on paper; 11$^{3}/_{4}$ × 13$^{1}/_{4}$"
Signed: upper left
Private collection, New York
(Fig. 80)

135. *Mr. Grimes and His Sundown Guitar* ca. 1985
Watercolor and collage on paper; 6 × 9"
Signed: upper left
Collection E. Boulware, New York

136. *Lady and the Blues* 1986
Collage and watercolor on board; 14 × 10"
Signed: center left
Collection Lou Milano, Charlotte, North
Carolina
Courtesy Jerald Melberg Gallery,
Charlotte, North Carolina
Provenance: Jerald Melberg Gallery
(Fig. 81)

137. *Lamp at Midnight* 1987
Collage and mixed media on board;
11 × 14"
Signed: lower right
Private collection
Courtesy Jerald Melberg Gallery,
Charlotte, North Carolina
Provenance: Jerald Melberg Gallery
(Fig. 84)

138. *Rocks on Breaking Surf* 1987
Watercolor on paper; 10$^{1}/_{4}$ × 14$^{1}/_{2}$"
Signed: lower left
Private collection
Courtesy Sheldon Ross Gallery, Birming-
ham, Michigan
Provenance: Sheldon Ross Gallery
(Plate XXV)

139. *Death and the Dancer* ca. 1987
Watercolor on paper; 39$^{3}/_{4}$ × 31$^{1}/_{4}$"
(framed)
Signed: lower left
Private collection, New York
Provenance: From the artist
(Fig. 82)

140. *Carnival Dancer* ca. 1987
Watercolor on paper; 40$^{1}/_{4}$ × 32$^{1}/_{4}$"
(framed)
Signed: center right
Private collection, New York
Provenance: From the artist
(Fig. 83)

141. *Blue Rain, Mecklenburg,* 1987
Collage and mixed media on board;
30 × 40"
Signed: center right
Collection Mr. and Mrs. E. Thomas
Williams, Jr., New York
Provenance: From the artist

INDEX

Unless otherwise indicated, works are by Romare Bearden.